Doubleday

NEW YORK LONDON TORONTO SYDNEY AUCKLAND

Crowns

Portraits of Black Women in Church Hats

Michael Cunningham

Craig Marberry

Foreword by Maya Angelou

PUBLISHED BY DOUBLEDAY
a division of Random House, Inc.
1540 Broadway, New York, New York 10036

DOUBLEDAY and the portrayal of an anchor with a dolphin
are trademarks of Doubleday, a division of Random House, Inc.

Book design by Maria Carella

Foreword copyright © 2000 by Maya Angelou

Library of Congress Cataloging-in-Publication Data
Cunningham, Michael, 1969 Feb. 27–
Crowns: portraits of Black women in church hats/
Michael Cunningham, Craig Marberry.—1st ed.
p. cm.
1. Women's hats—United States. 2. Afro-American women—
Costume. 3. Afro-American women—Religion. 4. United
States—Social life and customs. 5. United States—
Religious life and customs. I. Marberry, Craig. II. Title.
GT2110 .C87 2000
391.4′3—dc21
00-043176
ISBN 0-385-50086-6

10

For our favorite hat queens: our mothers,

Patricia Cunningham

and

Janet Grace Hill

But every woman that prayeth or prophesieth
with her head uncovered dishonoureth her head.

I CORINTHIANS 11:5

Our crowns have been bought and paid for,
all we have to do is wear them.

JAMES BALDWIN

Foreword

Sundays are a precious gift to hardworking women who have labored unceasingly through the workweek. Remuneration is rarely commensurate with the outlay of energy. That is to say, working women work large and are paid small.

They generally use Saturdays to tend to home matters; i.e., to clean the house, wash and iron the clothes, and cook for the coming week. They usually find their first deep breath around bedtime on Saturday night.

And then Hallelujah, Hosanna! Sunday morning comes. If the woman is African American, she has some fancy hatboxes on a shelf in her closet. She will have laid out the clothes she plans to wear to church, the stockings and the shoes, but the choosing of the hat is saved for Sunday morning itself. The woman may, depending on how many she has, lay them all out, but not on the bed (it is said to be bad luck to put a hat on the bed). She may try on each hat two or three times before she dresses, just to see which one goes with her most recent hairdo.

But, finally, after the bath, after rubbing down her arms, legs, and neck with sweet-smelling lotions; after she has put on her best underclothes (don't wear raggedy underclothes—you may be in an accident and have to go to the hospital, and what would the nurses and doctors think of you if you had safety pins in your brassiere?), she is ready. She dresses in the finest Sunday church clothes she owns, layers her face with Fashion Fair cosmetics and sprays herself with a wonderful perfume, and then she puts on THE HAT, and it is The Hat.

She looks at her reflection from every possible angle. And then, she leaves home and joins the company of her mothers and aunties and sisters and nieces and daughters at church whose actions had been identical to hers that morning. They too had waited longingly for the gift of a Sunday morning. Now they stroll up and down the aisles of the church, stars of splendor, beauty beyond measurement. Black ladies in hats.

To a compliment directed at the hat, each Black lady will give a little frown and deprecatingly say, "This thing? I almost didn't wear it it's so old." As she turns away the Black woman's smile is resplendent.

MAYA ANGELOU

Interviewer's Note

When the Apostle Paul wrote an open letter to the Corinthians (I Corinthians 11:5), decreeing that a woman cover her head when at worship to symbolize her obedience to God and the church hierarchy, he could not have imagined the flamboyance with which African American women would comply. For generations, black women have interpreted Apostle Paul's edict with boundless passion and singular flair, wearing platter hats, lampshade hats, why'd-you-have-to-sit-in-front-of-me hats, often with ornaments that runneth over.

These captivating hats are not mere fashion accessories. Neither, despite their biblical roots, are they solely religious headgear. Church hats are a peculiar convergence of faith and fashion that keeps the Sabbath both holy and glamorous. I was eager to explore this cherished African American custom.

From the very beginning, I knew this project was a gift. I believe that God leads through whispers. The moment a friend, Chuck Wallington, told me that Michael was taking photographs of women in church hats, I could almost hear their voices. I had no idea what the women would say, but I knew their stories would be original and enchanting.

In all but a few cases, the portraits were shot before I conducted interviews. I would study a photograph and wonder, *Where will this woman take me today?* Usually, I guessed wrong. Who would have supposed, for instance, that Mrs. Sanclary Sanders (pictured on the cover), with her iron jaw and solemn eyes, would share such a comical tale about the ugliest hat ever made?

I conducted most of the interviews in the home of each participant. Before each interview, I sat in my car and said a silent prayer. *Use me, Lord. Help me. Guide me. Open my*

eyes to see. Open my ears to hear. After that, I began each interview with a perfect peace, a quiet assurance that I'd find Her Story. And, in the end, the participants shared fascinating experiences—sometimes sorrowful, sometimes humorous, but always insightful.

The book was nearly complete when I realized it contained no women from the Church of God in Christ (COGIC), the nation's second-largest black denomination. My family, I joked, would be excommunicated for the omission because I grew up attending a COGIC church in Chicago (St. Paul Church of God in Christ), where magnificent hats were as plentiful as Bibles. I found three COGIC women (Mrs. Janet Oliver, Ms. Charlene Graves, and Mrs. Mable Scott), who express distinct impressions of the annual COGIC convocation in Memphis—an official spiritual gathering and unofficial hatfest.

The women featured in this book own an average of fifty-four hats each; seven own one hundred or more. Attorney Beth Hopkins owns the fewest: three. Rep. Alma Adams owns the most: more than 350. When I was a reporter for an ABC affiliate in North Carolina, I interviewed Rep. Adams on several occasions. Each time, she wore one of her trademark hats. When I called to invite her participation in the book, she quipped, "How can you publish it without me?"

These women touched me. My arms sprouted goose bumps as Attorney Hopkins described the hats in the church of her childhood, hats that seemed alive with expression. My eyes glistened as Dr. Adnee Bradford sang—lovingly, sorrowfully—the spiritual her father sang fifty years ago when he came up the walkway after dusk. And I nearly slid off a sofa in laughter as Mrs. Peggy Knox recited her hat-queen rules of etiquette.

I love these stories. I love these women. I think you will, too. From the very beginning, I saw that my challenge was to elicit from these hat queens stories as individual and compelling as the hats they wear. That indeed happened. But not because of me. It was a gift, promised in a whisper.

CRAIG MARBERRY

Photographer's Note

The first question almost everyone asks is how I came up with the idea of photographing black women in church hats. In the Summer of 1998, a friend had just returned to Winston-Salem, North Carolina, from a family reunion. She told me how she had gotten a kick out of the big, fancy hats her relatives wore to Sunday service. Right then, I could see the book. I jumped on it the very next day. For generations, African American women have had such a deep passion for hats. I just knew that some other photographer had done a book already. I did some research on the Internet and, to my surprise, found nothing.

Right away, I called friends to find women willing to be photographed. I ran spots on the radio asking women to call my studio. I asked Mrs. Audrey Easter, who owns a boutique two doors down from me, to refer me to her customers. Sherrie Flynt-Wallington, a friend and advertising instructor, recruited many of the women on these pages and helped me publicize and arrange Sunday afternoon photo shoots at two local churches.

Before long, I had photographed dozens of eager participants. The women came from various religious denominations; they worked in a variety of occupations; they spanned three generations. The youngest, Mrs. Stacey Jenkins and Ms. Tamara Hill, were twenty-two. The oldest, Mrs. Jimmie Ruth Jones, was seventy-eight. I was so excited I could barely sleep. Thinking of the project took me back to when I was a child in Landover, Maryland, where my mother was an evangelist. We would visit churches and I'd see all the pretty hats.

I shot most of the early photos in my studio. I asked each woman to bring three or four hats. Some brought ten or more. But no matter how many beautiful hats they had with them, there was always the one hat that would create the perfect image. From a photographer's perspective, it was obvious.

Some of the shoots took as little as ten minutes; others required an hour or more. I took Dr. Shirley Manigault's portrait at sunrise in front of an outdoor sculpture on the campus of Winston-Salem State University, where she teaches. The temperature that December morning was thirty degrees and it goes without saying that we moved quickly. Ms. Deirdre Guion's portrait, on the other hand, required her to make three trips to my studio. Her magnificent hat worked perfectly in her first portrait, but I thought a different suit would complement it better. She agreed and came back for a second session. I adjusted the studio lights and she touched up her makeup, but when she opened her hat box she had brought the wrong hat. She drove back home. The third session was the charm.

My original vision was a book that contained photographs and poems. Journalist Craig Marberry had a different idea. Two months after I started taking photographs, Craig heard about the project. We had met five years earlier through a mutual friend. Craig looked over some of the portraits and said, "This is stunning work. But there's important oral history under those hats. I'd love to interview these women." That was the beginning of our partnership.

Some people have asked me why I chose to photograph the women in black and white instead of color. I didn't want the photographs to feel or look like fashion photos. I also felt that color would have placed too much emphasis on the hats themselves instead of the women wearing them. Most of all, I thought that the black-and-white medium would create a look of fine art. I want the people who look at each photograph to reach in deep and discover something special about the crown *and* the queen it adorns.

MICHAEL CUNNINGHAM

When I was growing up, [my mother] always looked much more glamorous than I did.

BETH HOPKINS (RIGHT)

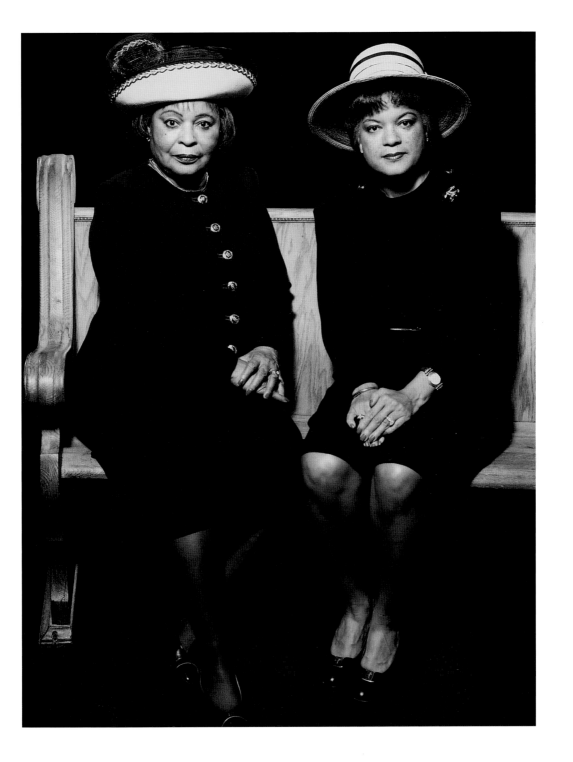

Beth Hopkins, 47, with mother, Grace

Adjunct law professor

Back when I was a little girl in Petersburg, Virginia, I thought hats had a mind of their own. Every woman in our church, Nazarene Baptist Church, wore one. Big women wore big hats with big crowns and big brims; little women wore little pillbox hats. I'd sit next to my mother and watch all the hats in front of us express themselves.

If the hats liked what the preacher said, they'd bob up and down. If the hats liked a song, they'd sway from side to side. If a hat thought you were talking too loud, it would whip around in your direction. And if a hat was *really* angry with you, its brim would dip just above a mother's eyes, and those could be some *fierce* eyes.

Style and fashion have always been important to my mother. When I was growing up, she always looked much more glamorous than I did. I'd go out of the house in just about anything and she'd say, "Oh, no. You need to come back and redo this."

If you want a real experience, go with my mother to buy a hat. When I was a teenager, it was a big challenge. I'd find a hat I really liked, try it on, and my mother would say, "Hmm." I'd say, "What, you don't like it?" She'd say, "No, no. That won't do. Try this one, dear."

One Sunday, I dared not to wear a hat. I think I was sixteen or seventeen, and trying to assert my independence. I did wear the hat to church, but took it off during Sun-

day school. To understand how scandalous this was, you have to understand that no young lady at our church had *ever* gone without a hat. It was considered to be poor taste. You weren't fully dressed unless you were wearing your hat, black patent leather shoes, and white gloves, and carrying a purse. One followed the other. *Always.*

So, after Sunday school, I told my girlfriend to save me a place in the sanctuary. I walked in five minutes late, to make an entrance, and sat next to my girlfriend, well away from my family.

Mothers can have outrageous peripheral vision.

My mother's hat turned around and those angry eyes followed. She gave me a look that made me want to drop dead. My girlfriend said, "Girl, you in trouble now."

When I got home, a battle ensued. "I'm sixteen and grown," I told my mother, "and I don't *have to* wear a hat." I lost my phone privileges for a week, and that was a killer at sixteen. I guess you know that I wore my hat from then on.

If you like the hats in the picture, give my mother the credit. They're both hers. She looked through my hat collection—all three of them—and wasn't very pleased. Suspecting as much, she had brought over eight hats of her own.

Before she selected the one I'm wearing, I went through a "Nope," a "Well, let's try the next one," and a couple of "Hmms." I'm forty-seven, a wife and mother, a law school teacher, and a former assistant attorney general, but my mother's still dressing me.

If a woman wears a hat all the time, she's going to look naked in the casket without one.

CARMEN BONHAM

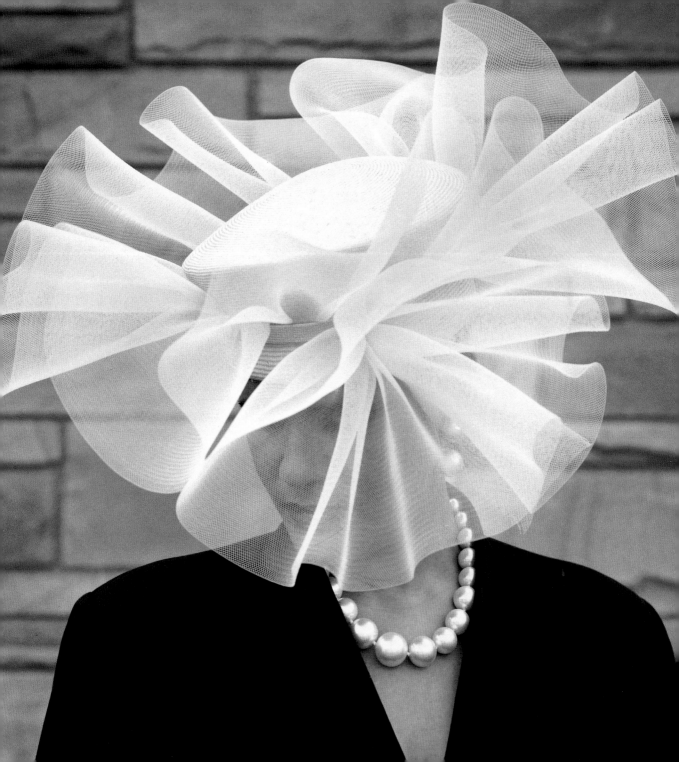

Carmen Bonham, 43

FUNERAL DIRECTOR

I never was interested in hats until I became a licensed funeral director in 1981. I think I must have worn hats in a previous life, because ever since I bought that first one, I love a hat. At a funeral, I've got to have on a hat.

I grew up in the business. My father owned a funeral home, but I never was interested, so I moved away. But when my father got sick, I left California and joined the business. I asked him if I should wear a hat because my mother always wore a hat, being the good mortician's wife. My father said, "Yes." So I bought a big, beautiful feather hat.

Whenever I directed a funeral, people would be looking at my hat. So I bought some more. People would say, "Girl, you can really wear them funky hats." One white lady told me I could wear a paper bag on my head and look all right. I came home and rolled a paper bag up and put it on my head. I looked at myself and said, "Humph, she just telling a tale."

One time, not long after I got started, some old neighbors lost their mother, Miss Lizzie. A sweet lady. Always kept pretty flowers in her yard.

Miss Lizzie always wore hats. And when her daughter came in for the consultation, she asked if Miss Lizzie could be buried in a hat. We told her, yeah, we can do anything you want. But I was really worried. I'd never seen a woman in a casket with a hat on. We'd never done that.

It was a pretty hat: white straw with a lot of lace. But it had this wide brim. I thought I was going to have to split the brim in the back to make it lay flat on the pillow. But I folded it instead and that worked out.

And then I noticed that the brim was still high in the front. I said to myself, *How in the world are we going to close that casket?* But then I remembered that caskets have this crank that lets you lower the mattress. So that gave us enough clearance.

Miss Lizzie was in her pretty white suit and her pretty white hat. The family loved it. Everybody loved it. When people came from her church to view the body, they said, "That's her! Oh, that's her!" You know, if a woman wears a hat all the time, she's going to look naked in the casket without one.

These days, we bury more women with their hats on. Some families say, "If it don't work, don't worry about it." But I always make it work. Yeah, I'm going to make it work.

Last year, one of my best friends in the world died. She was buried in a hat, too. This lady came in and looked at her and said, "Lord, she's walking around heaven sharp today!" Some women just love dressing up for the Lord. When it's my time, I think I want to be cremated. Otherwise, who'd do my hat up right?

We marched in with our hats and gloves and all the

A&T girls in the bleachers

started pointing and laughing at us.

OLLIE McDOWELL

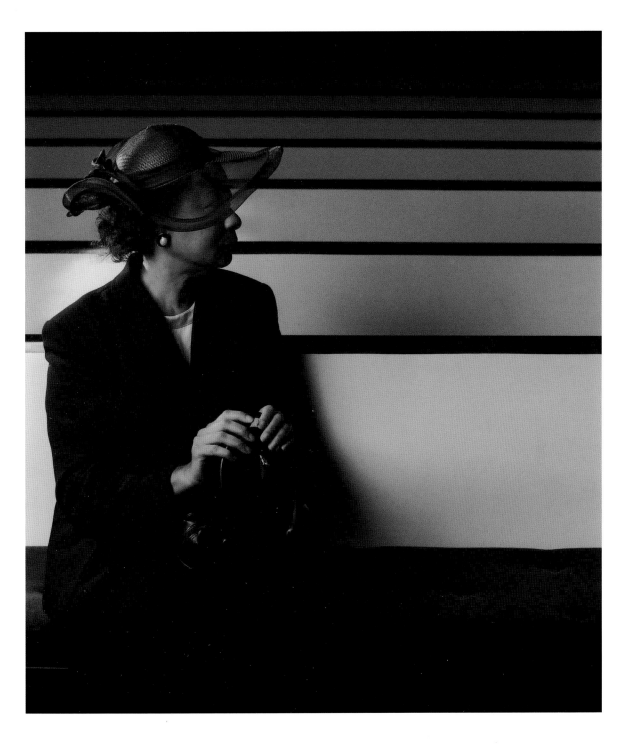

Ollie McDowell, 59

COLLEGE ENGLISH PROFESSOR

I grew up in Jefferson, Georgia, which is about fifty miles north of Atlanta. Jefferson is about as big as a classroom. We're talking *country*. My father was a Presbyterian minister. In 1958, he gave me a choice between two colleges for young women: Bennett, in Greensboro, or Spelman, in Atlanta. I chose Bennett because it was three hundred miles away.

Bennett sent me a letter that explained the dress code. We had to wear hats, gloves, heels, and stockings to chapel and whenever we went off campus. Students had to look like young ladies in public. That included all the football games and all the basketball games at A&T State University, the college next to our campus.

The dress code was fine with me. I thought that was how girls in college were supposed to look, until the first time we went to a football game. We marched in with our hats and gloves and all the A&T girls in the bleachers started pointing and laughing at us. We couldn't really take off our hats and gloves because our president went to all the games.

Bennett was founded in 1873 by the Methodist Church to educate freed slaves. It was coed at first, but focused on educating young women exclusively in 1926. The college had a tradition of producing well-rounded, well-educated graduates. The dress code was part of that tradition.

My roommate, Patsy Ruth, was a rebel. She didn't like all those rules. She hated nice hats, so she bought a million berets, just to cover her head with something. Patsy Ruth and

I went shopping one day. Whenever freshmen went off campus, we had to go in groups of two or more. And we had to wear hats, heels, and stockings. Patsy Ruth decided that she was going to go bare-legged and wear sandals. She might have worn flip-flops, horror of horrors. But I was correct: I had on my hat, heels, and my stockings. I followed rules.

Patsy Ruth and I were walking down Elm Street and this car pulled up beside us. We heard this voice: "Young lady, where are your stockings?" It was Bennett's president, Dr. Player. She was a firm woman, soft-spoken but firm.

Now, students attributed all kinds of super human powers to Dr. Player, but we couldn't figure out how she could be driving by and notice that Patsy Ruth didn't have on stockings. Because in those days, we wore plain, brown stockings that looked just like your skin. Then Dr. Player said, "Get in this car before you disgrace the school!" Patsy Ruth and I got in the car. "Aren't you ashamed? You have to be taken back to campus like a child?" Dr. Player considered that punishment enough. Good thing Patsy Ruth had on a hat.

There was only one time when Dr. Player said we didn't have to wear hats off campus: when we were picketing Woolworth's because they wouldn't serve blacks. Some students would go in and sit at the "Whites Only" lunch counter and some, like me, would march outside with picket signs. One of my signs said, "Jim Crow must go!" That protest helped desegregate lunch counters throughout the South. It's kind of funny: It took a civil rights movement to get those hats off our heads.

 Listen, never touch my hat! . . . Admire it from a distance, honey.

PEGGY KNOX

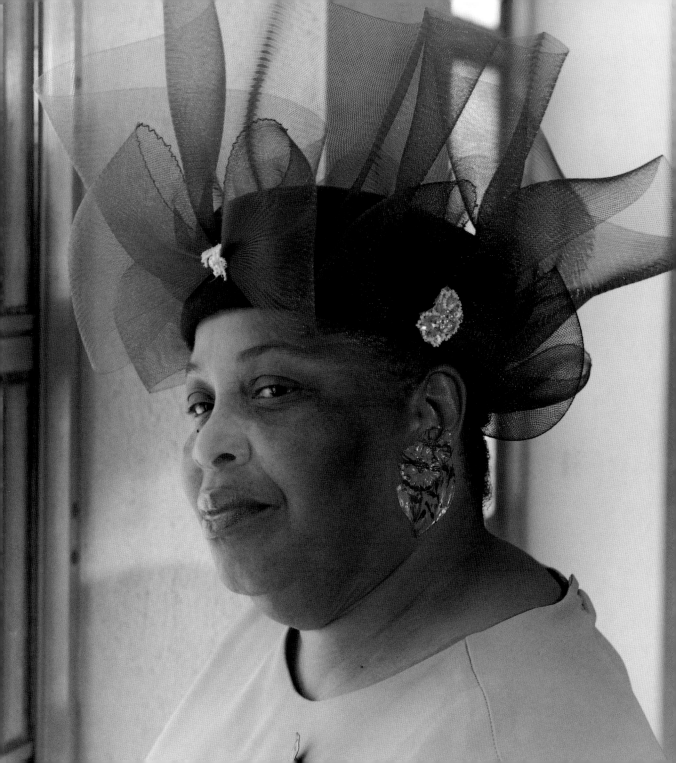

Peggy Knox, 58

CHILD CARE PROVIDER

I'm a hat queen. Got about thirty hats and I make them look good. When I hat shop, I look for a hat with the right amount of stuff on it. Stuff looks good when it just jumps out. That's what you call a "hit-ya" hat: a lot of stuff that jumps out at people when you enter a room.

The hat I'm wearing in this picture is a hit-ya hat. It was made by a woman who used to own a hat shop. She was putting this hat together when I walked up on her. At that time, she only had one ribbon on the hat. I said, "What else are you going to do with that hat? I like stuff. Are you going to add more stuff?" She said, "Well, sit down. I'm going to fix it for you." And this is what she came up with. She's awesome!

I don't like little hats. I don't like big ones, either. This one is just about right, don't you think?

Listen, never touch my hat! If you don't know, I'm gonna tell you. Don't do it. Not the hat. The only person who'd touch a woman's hat is someone who doesn't wear hats. Admire it from a distance, honey.

Sometimes people touch it by accident, but that's still no excuse. Like when I'm sitting in the pews on Sunday and somebody behind me starts clapping to a song and knocks my hat, or somebody gets up to pray or something and knocks my hat. All that time you spent fixing it just right on your head is gone, just like that.

Whenever I hear any movement behind me, I duck. But they still get me from time to time. You gotta be careful if you're sitting behind a hat queen.

Same thing with a hug. Church folk like to hug, but there's a certain way to hug a woman in a hat. You can't get all up on her, grabbing her around the neck. If you do that, you must be a person who doesn't wear hats. Because if you wear hats, you already know you're not suppose to get that close when you hug. Both people have to tilt their heads way to the side, in opposite directions, and leave a little space between you. It might sound funny, but it's true.

Over the years, you learn ways to keep your hat on your head:

- Don't let people touch the hat.
- Don't let people knock the hat.
- Don't let people hug too close.

Those are the hat-queen rules. Don't break 'em.

My hair turned brittle, short, uneven . . . The only time

that it didn't matter was on Sunday because

I kept my nice hats on all day.

CASSANDRA PATTERSON-BROWN

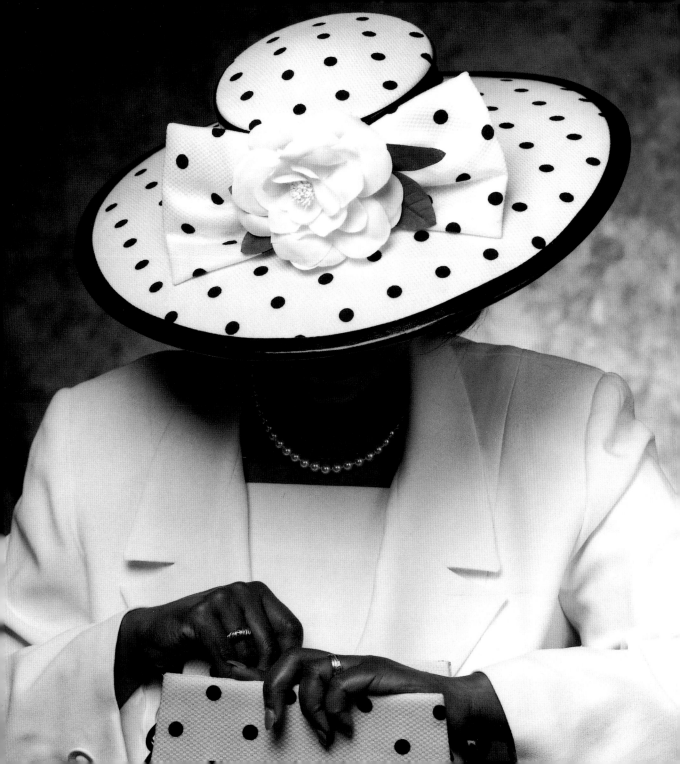

Cassandra Patterson-Brown, 45ish

CUSTOMER SERVICE COORDINATOR

When I was twenty-two, I got my first job in Buffalo, New York. I worked for the Neighborhood Housing Association. It's freezing in Buffalo during the winter, so I always wore a warm hat to work. Cheap, wool skullcaps. When it got warmer, I wore tams to work. I'd save my nicer hats for church.

I had a new job, new atmosphere, new friends. Something new all the time. It was a lot of stress. After a while, I noticed my hair was getting thin. My hair had always been long and thick. But all of a sudden, I had a lot of breakage. I thought it was my nerves.

I'd get up every morning and just stare at the hair in my comb. It was like I was shedding. I'd pull my hair from my comb and flush it. My grandmother taught me that. When I was little, my grandmother used to say, "Don't put your hair in the trash can. Flush it. Otherwise, somebody might play with it and give you a headache." So when my hair was falling out, I kept my commode real busy.

My hair turned brittle, short, uneven. It was a mess. All I could do was pull it back in a ponytail. I hated having to look like that at work. The only time that it didn't matter was on Sunday because I kept my nice hats on all day. I'd put my good hats over my awful hair and feel like I was styling.

I couldn't figure it out. I thought maybe my curlers were breaking my hair off. So I started wrapping my hair at night with a beautiful silk scarf my sister bought in Japan. One Sunday, I wore that scarf to church under my nice hat. This little girl, who

was special—she was about nine but she hadn't really grown up in her mind—she embraced me and knocked my hat off by accident. There I was in the middle of all these people with a scarf tied around my head. I was so embarrassed.

People say your hair thickens when you cut it, so I kept cutting it back. But it still kept falling out. My hairdresser would ask me, "What did you put in your hair? What kinds of foods are you eating?" Finally, I decided to go to a new hairdresser. My grandmother used to say, "You gotta find a hairdresser with a growing hand." The old folks believe that some people have the touch; they can just touch your hair and automatically it will grow. My grandmother would say, "Go find Miss So and So. She got a growing hand."

I heard good things about this hairdresser named Torina. I went to her shop, sat in her chair, pulled the scarf off my head, and said, "Fix it." Torina figured out the problem. She said it was those cheap hats I wore to work. She said, "Wool can damage permed hair." A perm is a chemical relaxer, and chemicals and wool just don't mix. Torina said, "If you wear a wool hat, make sure it's lined." Torina brought my hair back to life.

Here's my advice: If you've got a perm, ditch the wool. It's not your nerves; it's your hats. And here's some more advice: Find a hairdresser with a growing hand.

ack when I got my first hat, some stores were "Whites

Only." That made you want to go in.

NANCY CARPENTER

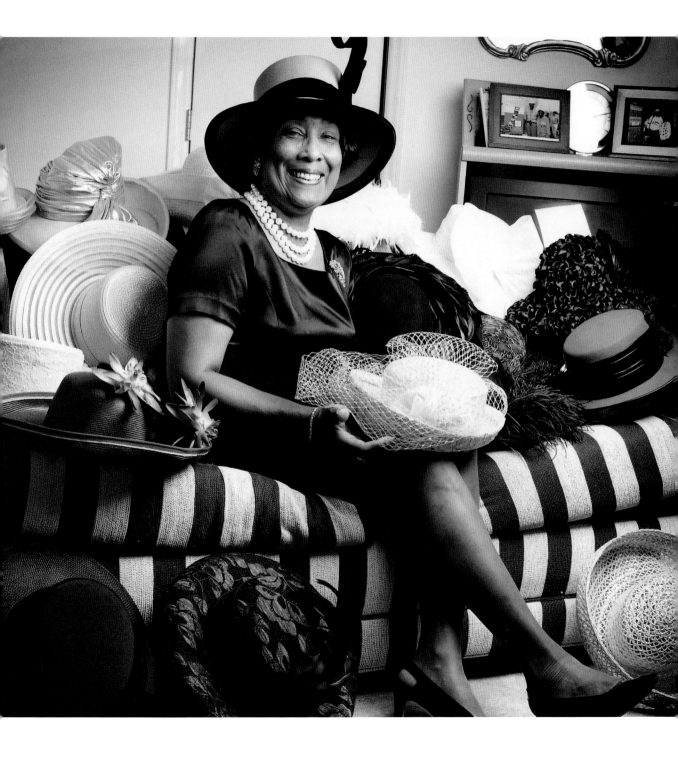

Nancy Carpenter, 61

AUDITOR (RETIRED)

*B*ack when I got my first hat, blacks could shop only in certain stores. Those were some different times. We didn't have shopping centers yet in Winston-Salem, so every Saturday we would go downtown. We'd go to Mother and Daughter, Anchor, and Davis, and all the other stores blacks could go to. Back then, you could get a nice hat for ten dollars, and you got a really good hat.

I married young, when I was eighteen. I bought my first hat right after that. The hat made me feel a little older, a little more mature. I didn't make a lot of money. Most blacks didn't have real good jobs. But I could use the layaway plan. Stores didn't have thirty-day layaway back then. You just paid until you could get it out. You could lay away a hat for a dollar and pay a little bit along, a dollar a week if you wanted.

One of the stores black people couldn't shop in was Montaldo's. It was "Whites Only." I saw quite a few hats in their window that I liked, but you just didn't go in. Being reared the way you were at that time, you didn't push.

Looking back on it, Montaldo's hats weren't any prettier. They didn't have anything so nice that we couldn't afford it. I guess it was just the thought that you couldn't go in there that made you want to go in. It wasn't a good feeling.

I'd walk by with my head in the air like, "I'd like to shop in here. But it doesn't bother me that I can't." I stuck with that attitude. "My money's green, too. If you don't want it, so be it."

In the sixties, we were finally allowed to go in Montaldo's. The first time I went in, it made me feel good to show them that I could shop there. I got all dressed up. I said to myself, *If I don't have but just enough to buy one hat, they'll never know it.*

I strutted in, playing the part just like I had money. I was going to get the prettiest hat I could afford. I'd pick one up, turn it around, take a look at the tag quickly, and put it back if it was too much.

When I went up to the counter with a hat, the lady said, "May I help you?" But she was looking down her nose like she was thinking, *I know she's not going to buy that hat.* That made me even more determined. If it took all the money I had at that time, I was going to purchase that hat.

I opened my purse. She said, "Will that be layaway?" I pulled out all these crisp bills and smiled. The lady looked shocked. I bought that hat, took my bag, and strutted out just like I strutted in.

Montaldo's closed down a few years ago. Some people might say they deserved to close because of the way they used to be. But being a Christian, you have to forgive. You just have to say that they didn't know any better. Funny thing was, by the time they closed, I owned about a hundred hats—more than they had in the whole store. And mine were prettier.

They say I look like Mama in my hats. Sometimes, in church,

I find myself sitting where she sat.

GLORIA SWINDELL

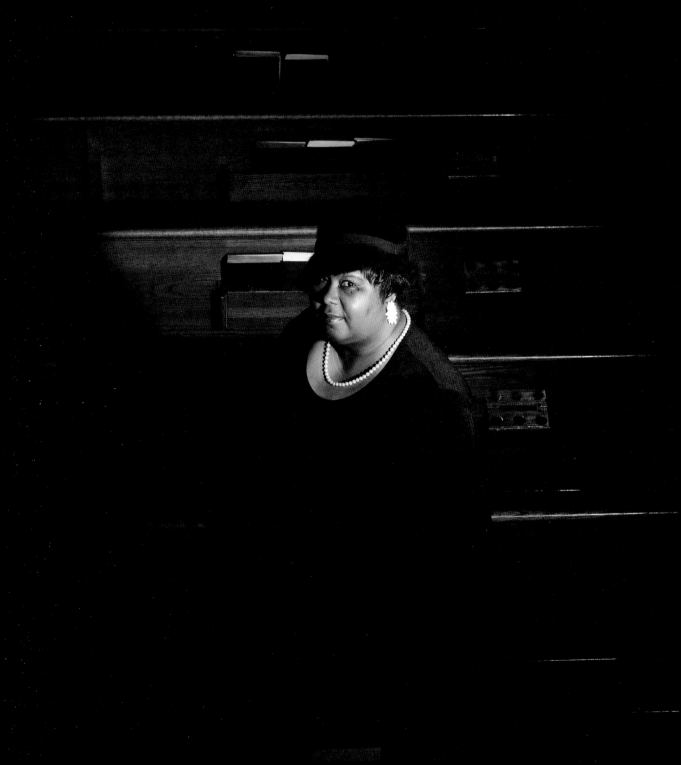

Gloria Swindell, 45

Health care specialist

My favorite hat is my mink hat with the black satin band. It was my mama's. Never thought I'd end up with it 'cause I didn't really know my mama. She left us, my brother Billy and my sister Linda and me, when I was three months old.

We grew up thinking, *What mother would just walk off and leave her children?* The only thing we were ever told was that she didn't want us. But I learned that she was afraid of Daddy.

Growing up, it was hard because we would see Mama at church. We didn't understand why she wouldn't reach out to us. Occasionally, she would give us money when she would see us. But we couldn't understand why she was so cold. It was like, "Hey, how y'all doing? I'll see you next Sunday." That's all she ever said to Billy, Linda, and me. So she kept her distance.

Mama was real attractive. I was proud of that, but sometimes it made me feel bad. She had all these beautiful hats and beautiful clothes, but I only had two dresses. I wore one dress on one Sunday, then the other one the next Sunday, back and forth like that.

I was maybe seven or eight when I first saw Mama in that mink hat with the satin band. After church, I said to her, "You look nice today." She said, "Thank you. I'll see you next Sunday."

When I was fifteen, Daddy's health got worse. He wasn't working much anymore and we knew we couldn't stay with him. Billy called Mama.

She had remarried, but Billy asked if we could live with her. She said yes. It was like a reunion to a certain extent, but we had all kind of mixed feelings about her. We got really close, though, Mama and us.

We were in the den one day—Mama, Linda, and me. The TV was on and it was storming outside. I said to my sister, "Mama's scared of thunder and lightning. Wonder why she got the TV on and the window up?"

Then Mama said, "Go get my hats out the closet." She told us to pick the ones we wanted. One of the ones I got was the mink hat with the satin band. Mama smiled.

Mama died a month after that. Six months' time after we moved in, Mama was gone. She'd developed breast cancer during the time we reconnected. Forgiving her before she died brought me a sense of peace of mind. I realized it must have been real hard for her to do what she did when we were little—walking off from Billy, Linda, and me.

They say I look like Mama in my hats. Sometimes, in church, I find myself sitting where she sat. And I wear that mink hat like she used to wear it, tilted to the side a little. One Sunday, my cousin said, "I know that hat. I remember your mama *wore* that hat, girl!" I said, "Yeah, I remember, too."

When I was about eight . . . I was going to teach myself

to sew a dress and [make a] hat.

LUCILLE MONROE

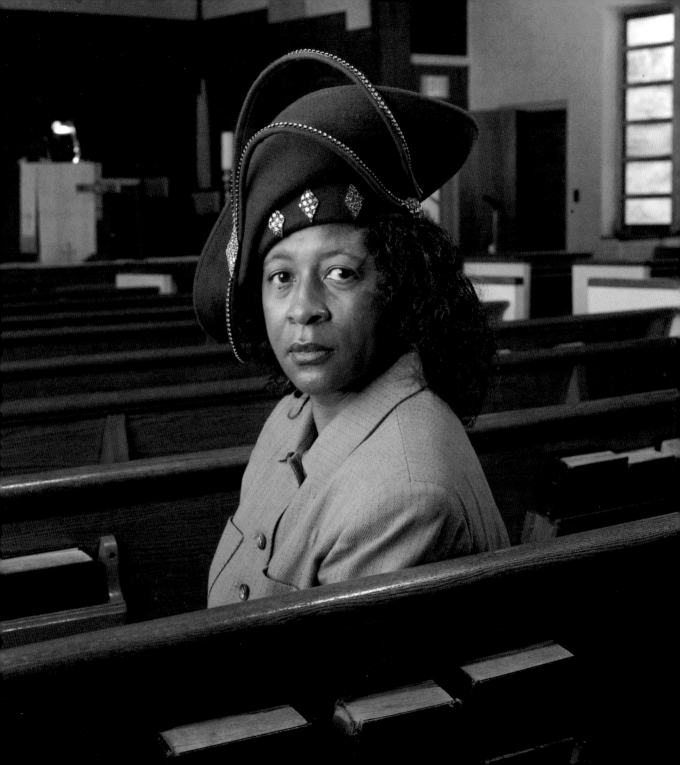

Lucille Monroe, 52

LAB TECHNICIAN

When I first saw this hat, I thought it looked wild and weird and crazy. I said, "I've got to have it!" I like different-looking hats. Maybe because all my hats were plain-looking when I was small.

I had five brothers and four sisters. My family was so big that Mama and Madaddy, that's what we called my father, Madaddy, they couldn't afford to go out and buy us girls hats and dresses. So Mama made hats and dresses for us.

Mama was a great seamstress. The sewing machine was in her bedroom. At the bedroom window. It was a manual machine that worked with pedals. Mama would sit on the piano stool and put on her eyeglasses and thread the needle. Then she'd turn the wheel to get it started. She'd work the two pedals with her feet to keep it going, pushing one then the other one, up and down, up and down. You could hear a soft *click-click* coming from her bedroom for hours at a time. *Click-click. Click-click. Click-click.*

Mama would make the hats from the same material as our dress. The hats were a little round piece with another smaller round piece on top and a ribbon that tied under the chin. They were plain, but I was very proud to wear what Mama made. Folks at church would say, "You look so nice in that pretty dress and a hat to match."

This particular day, when I was about eight, my older sister Shirley and I slipped into Mama's bedroom. I was going to teach myself to sew a dress and hat. Shirley was going to turn the wheel and I was going to work the pedals.

I sat on the piano stool and put Mama's glasses on. Then I started to thread the needle. But Shirley turned the wheel before I was ready and the needle went straight through my finger. I screamed loud enough to wake the dead. Shirley tried to turn the wheel back, but it didn't turn. My finger was stuck there.

Mama was out tending to the flowers, but it didn't take her long to get in there. She was so upset. She said, "I told y'all not to touch that machine!" She got my finger out and doctored it up just as nice. Then she stormed out the house.

Shirley and I knew she was going to get a switch from the hedge bush to whup us. A switch was about as long as Mama's arm. She'd slide the branch between her fingers to strip the leaves off. And when that switch hit you, it would wrap around your leg and sting so bad.

Shirley and I just started hollering. "Mama, don't get that switch. Mama, don't whup us." We called to Madaddy. We said, "Madaddy, please tell Mama not to whup us." We tried to hide under his shirt and behind him.

Shirley said, "Just lay down on the floor and hold your breath. Act like you died and Mama will stop whuppin' you." Shirley played dead but I was too afraid, so I got the worst of it. After that whuppin', I was double hurting. My finger and my, well, you know.

Messing with that machine got me away from trying to learn to sew. So you won't ever see me with a hat that I made myself.

When a COGIC woman walks in with a hat [on],

she walks in with an attitude.

CHARLENE GRAVES

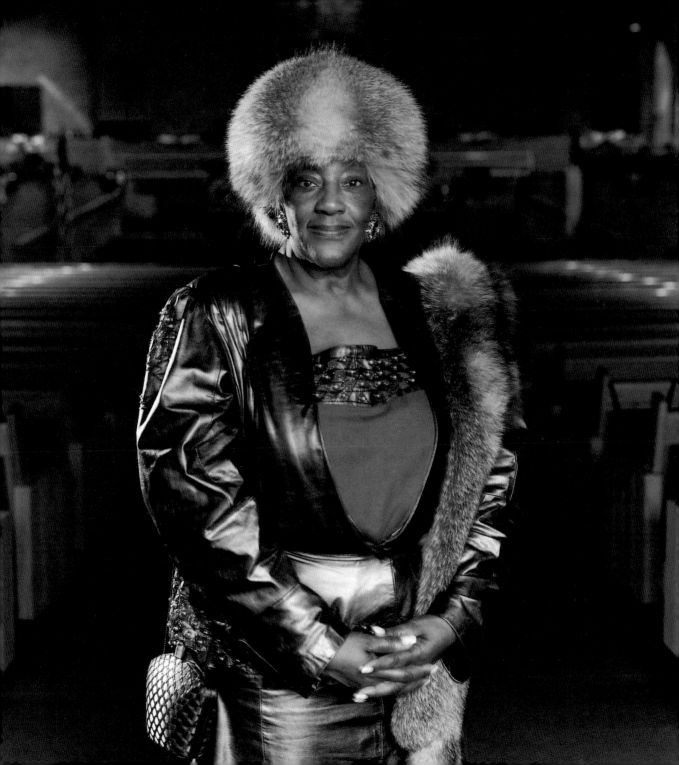

Charlene Graves, 58

RECEPTIONIST

We Church of God in Christ (COGIC) women wear hats that make a statement. Some of us think there's going to be a section in heaven just for us and our hats. We're known for our hats.

One Sunday last summer, I was eating dinner in a restaurant with two of my friends. This white man came up to us. He said, "You all must belong to the Church of God in Christ." I said, "Why do you say that?" He said, "It's the hats."

If you want to see some hats—every style, every color—you should go to Memphis for our annual convocation. It's a weeklong event. There were fifty thousand people there this year. I went for six days and took fourteen suits and twelve hats. I took about eight regular hats and four fur hats: a crystal fox, blue fox, black fox, and a mink hat. I carried them in a big leather drum case. I always pray before I check them at the airport. If my hats got lost, I would pass out.

When I fly to Memphis, I wear a hat on the plane. And if you go through a hub, you can recognize the Saints. They wear hats, too. We wave at each other. "Praise the Lord, Saint. See you in Memphis."

When November comes, everybody in Memphis knows it's COGIC time. Signs are everywhere: "The Saints Are Coming." I stay at the Peabody Hotel. White people who've never been to Memphis in November are trying to figure out, *Where in heaven did they come from?*

The Peabody has these trained mallards. The ducks perform twice a day in the

fountain in the lobby: They march to music and dance in the water. A lot of white people come with their cameras and they aren't sure if they want to watch the parade of ducks or the parade of Saints marching through in their finery.

Hat vendors make a fortune in Memphis. When you enter the exhibition part of the convention center, it's hats, hats, hats everywhere. You can pay from thirty to seven hundred dollars. Then you can go to the next booth and buy a suit to go with it.

Some of the services are held at Mason Temple, which is in a poor, black neighborhood. Over there, vendors are everywhere. A lot of people rent their yards to them. You see hats on fences, hats on lawns, hats on tables. You could spend hours looking at all the hats, and we do.

During the services, you sit there and try to be in the Spirit and get your shout in, but I look around and say to myself, *I want one of those and one of those and I want that one and this one*. One day, these two sisters came in, twins. They were very short and they had these big hats on that looked like spaceships—the biggest hats I'd ever seen in my life. I never did see their faces. They sat next to each other and when they stood up and clapped, the hats would just bounce. Everybody was watching them. I didn't want one of those.

When a COGIC woman walks in with a hat, she walks in with an attitude. But no matter how dressed up we are, we don't lose sight of the fact that we're saved. I never get so dressed up that I feel like the Lord can't use me, 'cause He will knock that hat off your head and knock you out.

ats were a sign of status for black women. Once you got

up on your feet, you bought some hats.

AUDREY EASTER

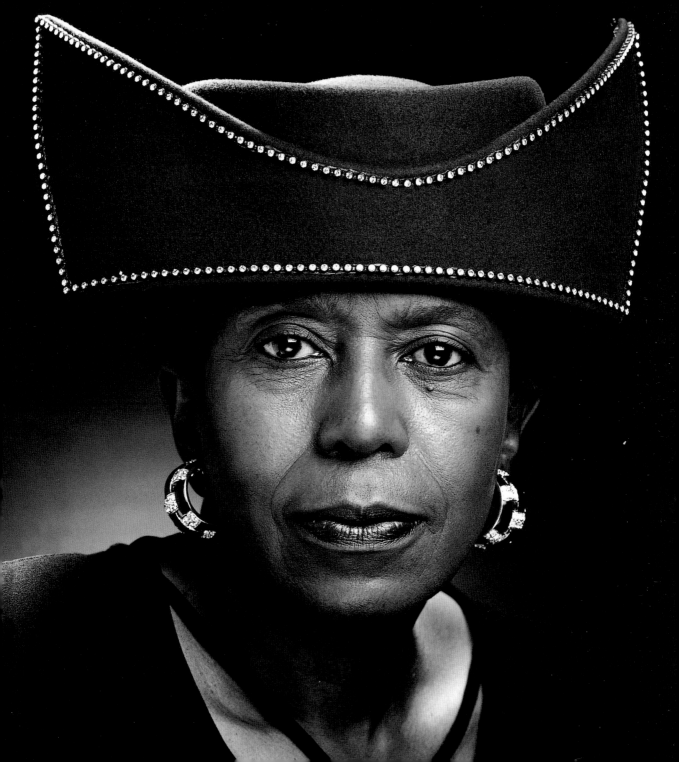

Audrey Easter *(Sixtysomething)*

Boutique owner

I was in my twenties when I bought my first car. It was a used '55 Ford Fairlane convertible, white with red upholstery. That car was so pretty. You know why women buy cars: because they're pretty, not because they're any good. I bought a new hat to wear while I drove it around. It was a black straw hat with a wide brim and a black band. Simple but elegant. I would go down the street in this beautiful white convertible with my wide-brimmed hat, thinking I was a movie star or something.

I'll never forget, that car had belonged to a white nurse at Baptist Hospital. White guys who knew her would blow their car horns at me, thinking I was her. You should have seen the look on their faces when they realized there was a black woman under that big hat.

Back in those days, hats were a sign of status for black women. Once you got up on your feet and started working, you bought some hats. To be ladylike, you also bought gloves and shoes with a matching pocketbook. The shoes would wear out first and you'd end up with all these stray pocketbooks, so you'd have to buy a whole new set.

It was always in my blood, the love of hats. Nice clothes and hats. That's why I opened my own hat shop three years ago, after I retired from the purchasing department of AT&T. My first thought was to open a shoe store, but then I realized that

there are just too many feet. There are so many different sizes that I'd have to carry too many shoes in inventory. But hats you can control. One size fits all. Even women with very large heads or very small heads can mount the same hat to make it work. It'll sit different on their head, but it'll work. So hats it was.

I don't want black women out there looking bad when they don't have to. I want my customers to walk out of my boutique with something they'll look good in. It's a mission, I guess. But a lot of black women like big, flashy hats, with wild feathers and things zooming every which way. I don't carry those. A lot of people like them, but I don't carry them because I don't like them.

I wish black women would wear more conservative hats. You shouldn't wear anything that you can't wear to church without blocking the view of people sitting behind you. Elegant, not overbearing. You want to be noticed, but you should want people to say, "Oh, that's a beautiful hat." Not, "God, look at that thing!" There's a difference.

I try to steer my customers in the right direction. I say, "I think this look might compliment you better." But if they're dead set on something gaudy, I send them around the corner. I guess different people have different tastes. But one thing's certain. If it weren't for black women, the hat industry would be out of business.

 s a little girl, I'd admire women at church

with beautiful hats.

SHERRIE FLYNT-WALLINGTON

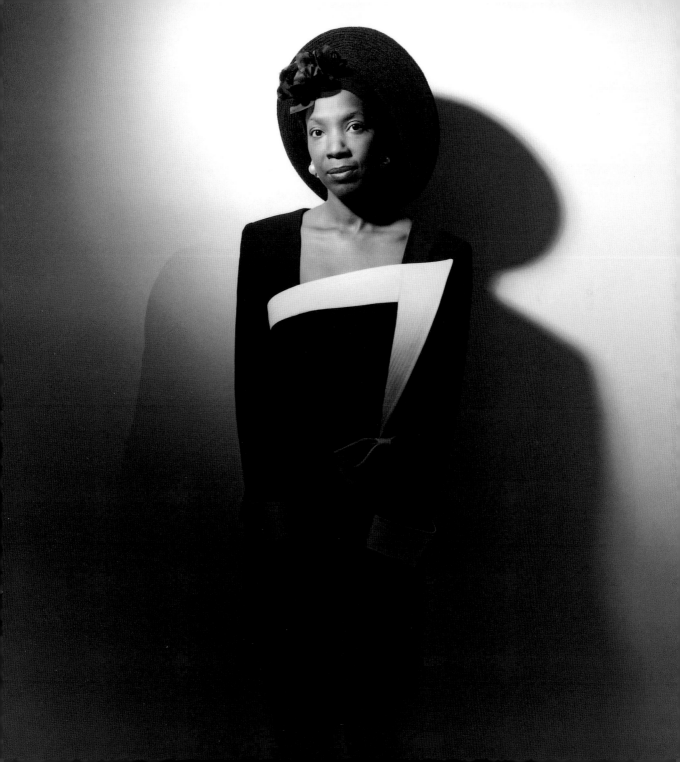

Sherrie Flynt-Wallington, 38

University advertising instructor

When some people look at me, they think I'm fragile. They think I'll crack like a shell, but I'm tough. I've known some hard times. People who've never known hard times have nothing to fall back on.

I grew up on a farm in Stokesdale. It's a really small town. Everybody knew everybody. You never paid cash at the grocery store. You'd say, "Put this on my mama's account." We never had a lot of money, we were poorer than poor, but we had our farm. It was in our family for three generations.

My mother left my dad when I was a child. People told her she was crazy. They said, "How are you going to make it with five kids?" But my father was abusive, so she left. When my grandfather died, people told my mother to sell the farm. But she said, "No, I promised my father I wouldn't."

Tobacco was the only crop we raised. When you were big enough to hand tobacco to someone, you were big enough to work. The schools in Stokesdale opened a few weeks late because the farmers needed their kids to help get the tobacco to market. You worked so hard for a little bit of money.

I've got two sisters and two brothers. I'm the baby. We never wanted to get up in the mornings. We woke up at five and it was always cold and the tobacco was still wet from the dew. It was still pitch dark because we didn't have streetlights in the country. We'd put on these raggedy overalls and old shoes—nothing good because that tobacco

gum is hard to remove. My sisters Lynne and Myrna and I would wrap our heads with those bandanna scarves.

Lynne and I would fold our scarves in a rectangle and just tie it on our head. We wouldn't even look in the mirror. But Myrna was so prissy and fashion-conscious. She would tie her scarf in a way that it looked like a hat. She looked like a model even in the tobacco field. We would get so mad at her. She would be all up in the mirror, taking forever.

We'd say, "Myrna, we're going to leave you." She probably hoped we *would* leave her. She hated getting so dirty and smelling like tobacco. I love her, but she thought she was too good to be out there. She'd always cry that her back was hurting, her back was hurting. My grandmother told her she was too young to even have a back. But one time, my mother said Myrna could go home. Lynne and I were mad as fire. But we fixed her.

One day, Lynne and I put tobacco worms on her scarf. Myrna hated tobacco worms. They were slimy, juicy-fat, and lime green. They crawled around her scarf for a while, then they crawled down her neck. She screamed and started crying. She was so upset she almost stripped her clothes off. We told her the worms were jewels for her crown. She was so mad at us. After that, she stopped being so prissy.

As a little girl, I'd admire women at church with beautiful hats. They looked like beautiful dolls, like they just stepped out of a magazine. But I also knew how hard they worked all week. Sometimes, under those hats, there's a lot of joy and a lot of sorrow.

 don't like to get dark ... I tan easily, so I like a straw hat

in the summertime.

TAMARA HILL

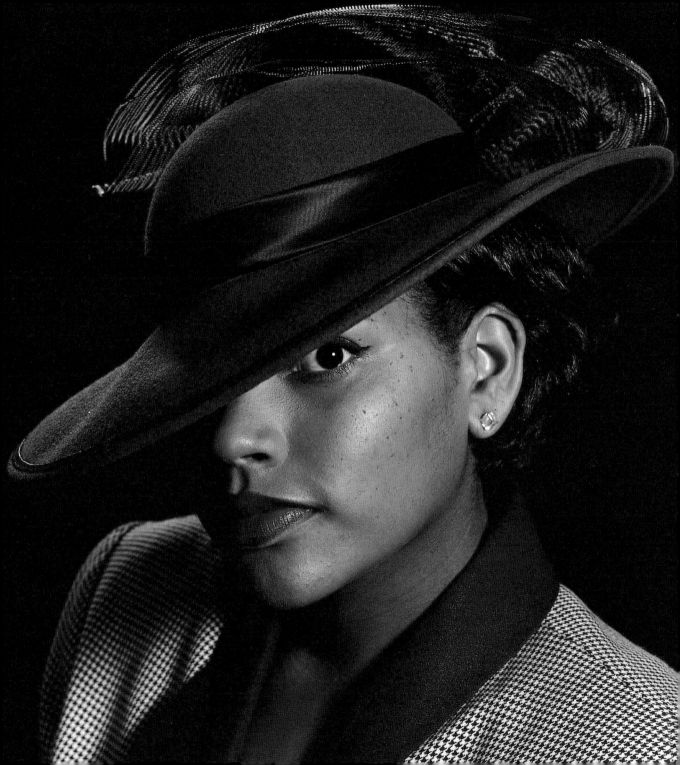

Tamara Hill, 22

COLLEGE STUDENT

I wear more hats in the summertime because I don't like to get dark. I don't have anything against dark skin, it's just that I like my complexion as it is. I'd call it a creamy caramel. I don't want to be any lighter, but I don't want to be any darker, either. I tan easily, so I like a straw hat in the summertime. A big one. Lots of shade.

I can hear black folk now; "That little high-yellow girl, who does she think she is?" Complexion is an issue among blacks. We still have a problem with that. The perception is that lighter-skinned people think they're better than darker-skinned people. And that darker-skinned people have resentment toward lighter-skinned people. We need to let that stuff go.

To me, it's not about that. I don't want to be any darker, but not because being dark is a negative thing. The majority of my friends are darker than I am and we don't have a problem. What I'm saying is that I like hats, but for me, they're also functional, not just fashionable. They keep the sun off.

When the sun gets to me, I just look overcooked. I feel like I can wear any color lipstick under the rainbow because of my complexion. But when I get dark, some colors don't work.

I have a friend who is very dark skinned, a beautiful, deep chocolate; looks like you can scrape it off with your finger and eat it. She won't wear red lipstick. She thinks

it's too bright for her. She won't wear white or bright clothing, either. I'm constantly telling her that she can pull it off, but she thinks she's too dark for it. But I guess I see what she means because I don't like how I look in some shades of lipstick when I get too tanned. Isn't that awful?

I don't know if hats are a dying tradition or not. I hope not, but I never really saw a lot of hats growing up. My mother never wore them, both of my grandmothers died before I was born, and when I went to church, I slept. I mean, I was a child. So I sort of discovered hats on my own.

I love the look of a hat when a woman knows how to pull it off, but I don't think most women my age have the passion for them that older women have. Maybe it's a generational thing. I think hair has something to do with it. Hairstyles are so trendy now. I think younger women put so much time and money into their hair that they don't want to mess it up with a hat.

When I get dressed to go to church, I'm going to meet the King, so I must look my best.

ADDIE WEBSTER

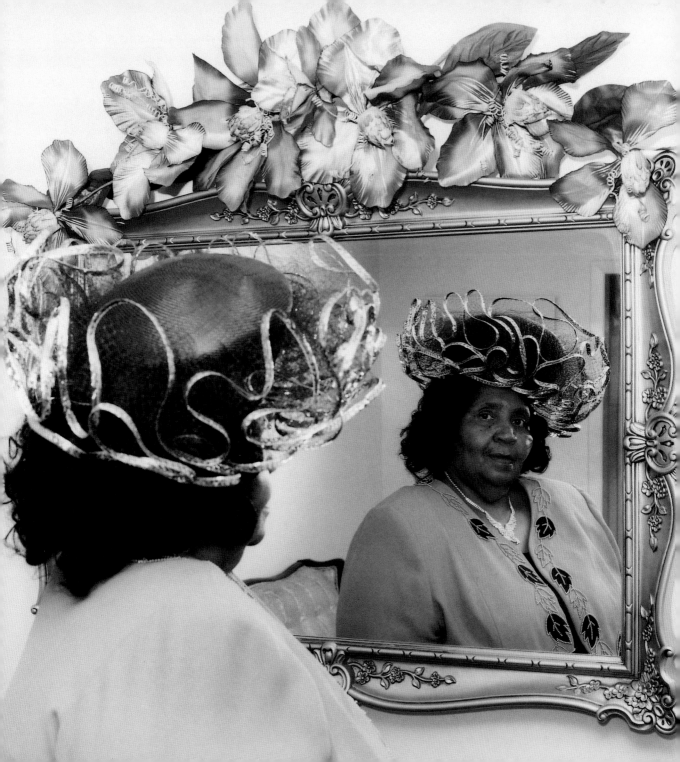

Addie Webster, 55

EVANGELIST

Before I bought this hat, I picked it up and looked it over. I said, "It's awful big." I put it back down. Then I picked it back up and I said, "No, it's not." It was very expensive, $159, so I put it back down. But then I said, "Well, I deserve this hat." So I picked the hat up and said, "I'm gonna carry this hat home."

I love good hats. Wish I could wear them every day, but I runs a laundromat, and I'd look stupid down there with a hat on my head. You're going to pay a lot for a good hat. I go for designer hats and they usually cost one or two hundred dollars. But you can wear a hat like that and not worry about going out and seeing yourself somewhere else. That's 'cause they're usually one of a kind. There's nothing worse than going to church and seeing yourself.

Years back, when I was raising children, I couldn't afford to spend a lot on a hat. I had four young boys. This one time, I paid about thirty or forty dollars for this hat. It was a black-and-gold pill-box hat with a big black bow. I loved that hat. It was gorgeous.

I wore it one Sunday and I thought I was looking good. I took my seat on the first row, ready to enjoy the service. Then I looked back behind me and saw her; I saw myself sitting there. And my hat didn't look good on this lady.

She wasn't looking at me. I don't think anybody else noticed, either. But it jumped

right out at me. I said, "Oh, no. Oh, my. Here I go." I wanted to go home and take my hat off. That was about the saddest day.

I wouldn't have minded as much if she looked like something in it. I didn't know the lady, but if I did, I would have gone up to her and said, "Now, honey, let me show you how to fix that hat."

Some women don't know how to wear a hat. They just sit it up there straight. I always cock mine a little to the side. Sometimes I'll even have the front in the back and the back in the front. I stand in the mirror and put the hat in different positions until I see something I like. When I get dressed to go to church, I'm going to meet the King, so I *must* look my best.

That Sunday when I saw the lady in my hat, I wanted to take mine off my head. But my husband was driving and I sho wasn't gonna tell him, "You need to run me back home 'cause somebody got on my hat." He would have looked at me and said, "Are you crazy?" But if I had the keys in my purse, I would have got up.

That lady, she kept wearing that hat. But she didn't see mine no more. Gave it away. Never put it on my head again. Some people can't afford to put a whole lot of money into a hat. But the truth of it is, if you buy a cheap hat, you might see yourself one day.

Sometimes [Mrs. Spainhour would] say, "Denise, I'm going to leave you my hats." . . . I'd say, "Well, make sure you leave me that one."

DENISE HARTSFIELD

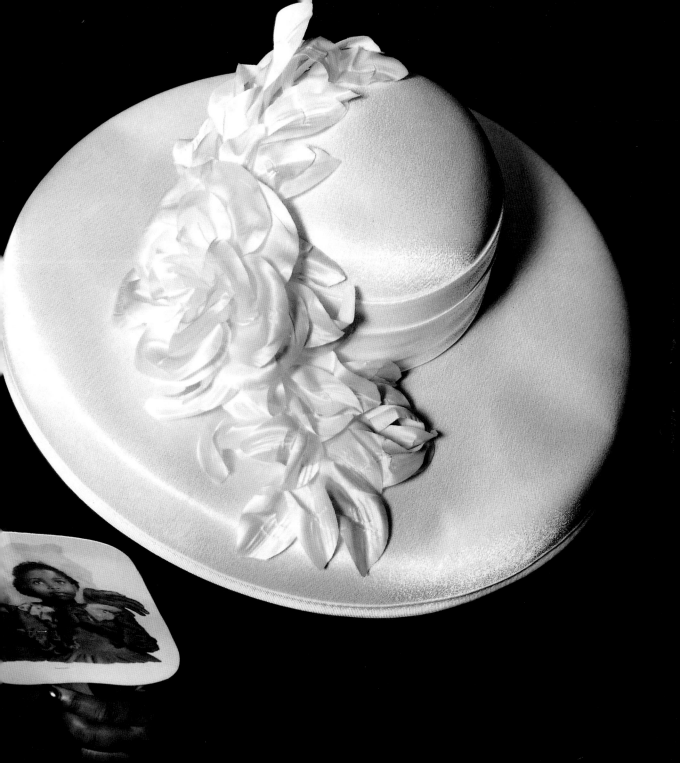

Denise Hartsfield, 44

SOCIAL SERVICES ATTORNEY

I grew up attending the St. Paul United Methodist Church in Winston-Salem. And Sunday after Sunday, I'd look for Mrs. Spainhour. I've always noticed and admired well-dressed women. She was an *extremely* well-dressed woman.

Mrs. Spainhour had a son, who is now a lawyer, but no daughters. I probably was an attractive little girl to her. We always sat together. I admired her so much, thought she was so pretty, and I just loved her hats.

She had unusual kinds of hats. Hats with feathers. Hats with veils. Not just your regular straw hat with flowers.

When I became a teenager, I started wearing hats myself. Every Sunday, Mrs. Spainhour and I would have an exchange about our hats. We'd talk before church. We'd talk after church. We even talked during church, truth be told.

"Oh, I like that hat," I'd say. She'd respond, "You're wearing that hat, girl." Or sometimes she'd say, "Denise, I'm going to leave you my hats." Then, just joking around, I'd say, "Well, make sure you leave me that one."

Then, one day, when I was in my second year at Spelman College, Mama called me. She said, "Mrs. Spainhour has died." I was shocked. Mrs. Spainhour had lived into her late seventies and it seemed like she'd always be around. Then Mama said, "She left her hats to you." I said, "Huh? She did what?"

When I got home, Mr. Spainhour told me to come pick out the hats I wanted. Mrs. Spainhour kept them in the basement. I couldn't believe my eyes when I saw all those hatboxes neatly stacked and labeled.

She had the winter hats in one corner and the summer hats in another corner. She was so bad, she even had *transition* hats. Most women don't have transition hats, something to wear in September and October, after Labor Day and before the official beginning of fall. That's when people say, "Don't wear white hats and don't wear straw yet because it's just country and wrong." When it's too hot for felt and wool, what do you wear? Mrs. Spainhour wore hats made of feathers or silk.

I went from box to box like a kid at Christmas. She had one of those long, stand-up mirrors in the basement. I stood in front of that mirror and tried on hats for what seemed like hours. I could remember Mrs. Spainhour wearing many of those hats and the conversations we had about them. I could even remember a lot of the outfits she wore with them.

There was a coral-color hat I kept looking for because I recalled how good she looked with her matching coral suit, trimmed in white with white buttons. I found it. In the end, I came away with about twenty. I wasn't sure how I'd feel going to get those hats, but it was a great day with good memories.

 y father would say, "Sis, where'd you get that hat?" That was his way of saying he liked to see me dressed up. He wasn't the kind to express his emotions, but I never questioned my daddy's love.

ADNEE BRADFORD

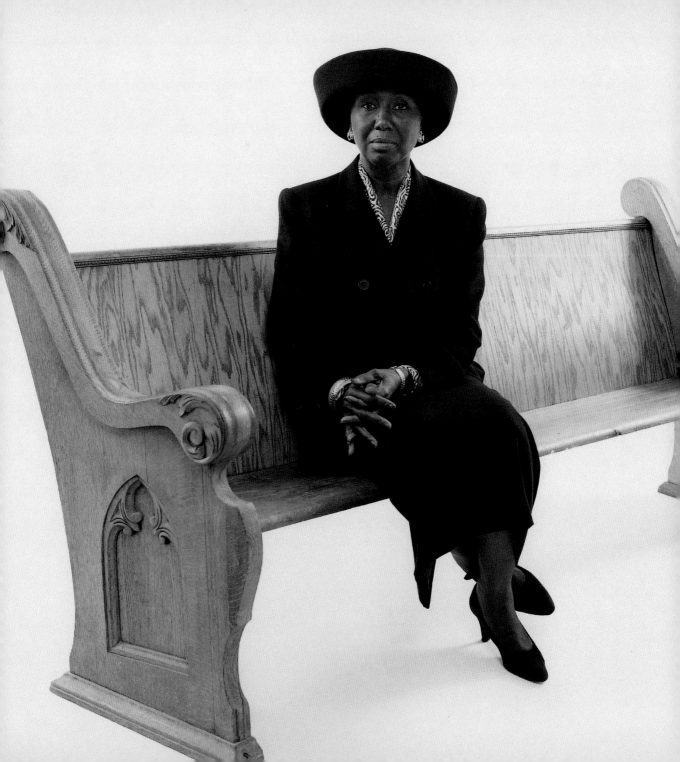

Adnee Bradford, 62

INTERIM CHAIR OF UNIVERSITY ENGLISH DEPARTMENT

I grew up outside Atlanta, ten miles south, in a community called Hapeville. It was where my parents bought their first house, a small, three-room house with one cement doorstep. The date on the doorstep said 1926. It looked like someone wrote it with a stick.

My daddy's garden ran along the side of the house. He grew sweet potatoes, okra, corn, tomatoes, squash, peppers, turnip greens, string beans. My father was a laborer, and he also spent twentysomething years pastoring two rural churches.

At about five o'clock in the morning, Mother was in the kitchen cooking biscuits and Daddy was out in his garden until it was time to eat and go to work. After work, he'd go back to his garden until supper time. Daddy was a hardworking man.

My younger sister, Betty, and I loved to meet him at the bus stop. I would see this brown figure in overalls coming up the dirt road. We'd run and catch him by the hand and say, "Hey, Daddy." He'd say, "Hey, you boys. What you been doing today?" It never bothered me. He had two daughters. He wanted two sons. So he called us boys.

I used to rely on Daddy to feel safe, and I think he knew that intuitively. If he got back from church after dark, he would sing his way to the door so not to frighten us. He might be singing:

> *Let Him come in,*
> *Let Him come in,*

Open the door,
Open it wide,
And let Him come in.

Daddy was not a good singer, but he liked singing. He also liked to tell me stories and point out things I might not have noticed. He'd say, "Sis, hear that train? That's the five-thirty to so and so." He'd show me things in the sky. He'd say, "Sis, see the crescent moon?" He'd tell me when it was time to bank the potatoes and kill the hogs.

My dad died on June 20, 1994. It was a Monday. He was eighty-nine years old. He was unconscious during his last days. I used to talk to him when we were alone.

I told him one day—and I think he could hear me—I said, "Daddy, do you remember how you raised butter beans and corn and okra and tomatoes, and how you would sing and tell me about the moon, and how you called Betty and me boys because you wanted boys, but you loved us just the same?" And I laughed. I just needed to tell him that he was the best father any daughter could ever ask for.

I didn't intend to wear a hat to my father's funeral; I intended to get my hair done, but there was no time. My daughters brought my little wraparound hat with an African motif. It was black with a bit of gold in it. It wasn't really the look I wanted for my dad's funeral, but I needed something on my head.

Daddy would have laughed at that hat. He'd see me with some hat on and just start laughing. He'd say, "Sis, where'd you get that hat?" That was his way of saying he liked to see me dressed up. He wasn't the kind to express his emotions, but I never questioned my daddy's love.

oing to church is a religious affair, but it's a social affair,

also. We put some serious thought into

what we're going to wear Sunday morning . . .

JACQUELYN JENKINS

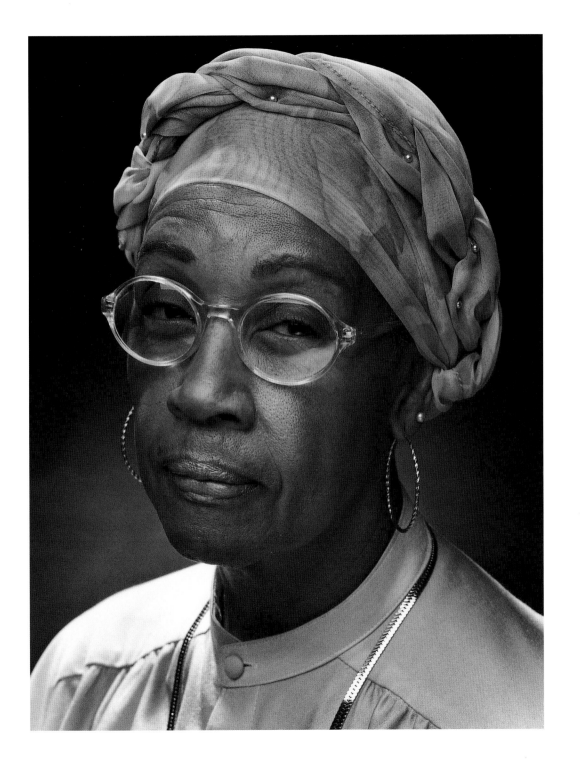

Jacquelyn Jenkins, 69

KINDERGARTEN TEACHER'S ASSISTANT (RETIRED)

You know, some women at my church pay two or three hundred dollars for those grand hats. Me, I just don't believe in putting a whole lot of money in a hat. But I get the biggest kick out of those fancy ones. I go to church early to get a seat on the front row of the balcony, just so I can look over at all those hats.

Some of them are pretty; some look outlandish. I say to myself, *My God! Why would she want that? It looks like an airplane getting ready to take off*. My friends tell me, "We see your head raising up and looking all around." I can't help myself.

African American women dress to the nines to go to church, more than any other women. It's part of our heritage. Our African ancestors always wore some type of headdress to decorate themselves. Slave women wore bandannas to keep the dust out of their hair, but they also added wild flowers to dress it up.

You have to remember that church was the only place slaves were allowed to congregate. And after slavery, there were "Whites Only" signs everywhere. So if you had something you wanted to show off and be in style, you'd wear it to church.

Going to church is a religious affair, but it's a social affair, also. We put some serious thought into what we're going to wear Sunday morning, especially our fancy headdress. But me, I wear simple hats: tams, straw hats, and scarves that I tie into hats.

I've been wearing hats ever since I can remember. I was raised in White Plains,

New York. Mom really doted on me because I was an only child. She would always fix my hair so pretty and put a tam on my head.

At night, Mom would wash my hair in the kitchen sink with a bar of Castile glycerine soap, which burned real bad if it got in my eyes. Then she'd put my hair in braids. I had long hair. And it was a pretty good grade of hair.

Early the next morning, my mom would say, "Come on, Jackie, 'cause you know we've got to comb your hair." She'd curl my hair—and not with a hot iron. She used a brush with a long handle. She'd take a strand of my hair and wrap it around the handle and brush it and pull it down. It would hang in a perfect curl, one of those big banana curls. She'd get the jar of Three Flowers Brilliantine, which was a perfumed hairdressing, thick like Vaseline, and she'd spread a little bit on her palms and put it on my hair. It smelled like flowers. Then she'd stick a little tam on top of my big curls. I can remember that like it was yesterday.

The kids at school would tease me. "Oh, look, it's little black Shirley Temple in her tam." It didn't upset me. I kept wearing my hats. And I've been wearing them for almost sixty-nine years.

When you present yourself before God, . . . there should be

excellence in all things, including your appearance.

SHIRLEY MANIGAULT

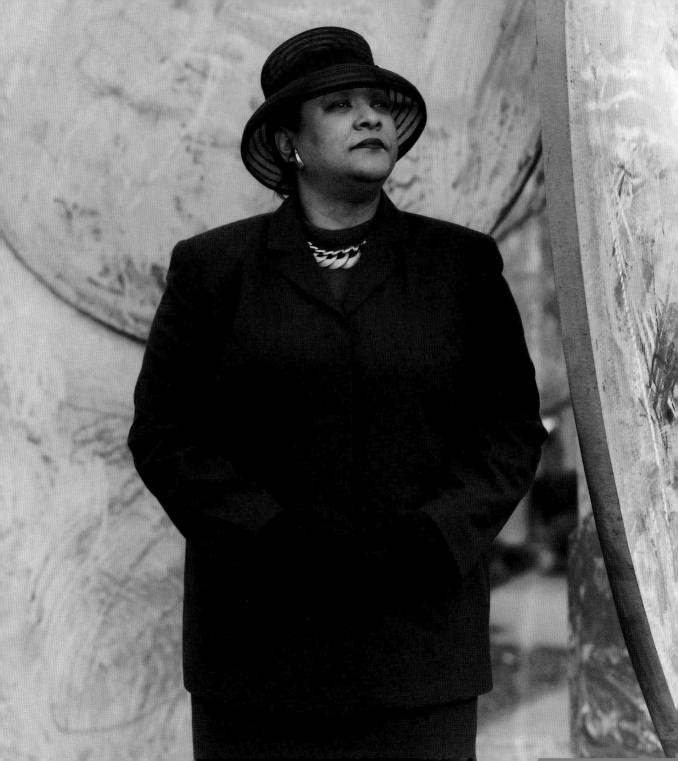

Shirley Manigault, 49

COLLEGE PROFESSOR

*H*ats are like people: Sometimes they reveal and sometimes they conceal. A hat expresses something about a woman, but it can also mask something.

When I look at myself in a hat, I see my mother. Mama would always say, "If you want to look good when you get old, don't drink, don't smoke, and don't run around." I remembered that. I don't drink and I don't smoke and I don't run around. Not to say that I haven't done those things, but I don't do them anymore.

Something else Mama would always tell me is, "Put something on your head. Put something on your head." Back then, I didn't like hats the way she did. Even now, I don't wear the kind of hats my mother wore. Mostly, she wore sophisticated hats. I like odd hats. I might have on clothes that look very conservative, but my hats are always odd-looking.

My mother always wore hats to church on Sunday, but as she got older, she wore them all the time, even when her health began to fail. I still have that image of her in my mind.

In my mother's day, for women to wear hats in church signified submission to authority and submission to God. Sometimes I don't think people can always explain the peculiarities of their culture. They can't always intellectualize about it, they can't always explain it, they just live it. For black women, hats are an important element of our culture.

For instance, black people tend to dress up when they go to church. My father was a brick mason and a contractor, so during the week he wore overalls. And Mama, she wore simple dresses around the house. But on Sunday, they'd put on their best and go to church.

I think that grows out of the African American tradition that says that when you present yourself before God, who is excellent and holy and the most high, there should be excellence in all things, including your appearance. It's a holdover from African traditions, the idea of adorning oneself for worship.

Women are the caretakers of culture. We teach the traditions, rituals, rites to our children more so than men do. I hear myself saying things to my son, Chad, that my mother used to say to me. No matter how I fight against it, I'm becoming my mother.

Mama died at age seventy-eight from diabetes and hypertension. Toward the end, she suffered strokes and heart attacks. But she'd recover remarkably and still get out in her hats. She'd visit people, she'd shop, she'd worship at Russel's Tabernacle CME Zion Church.

The day of Mama's funeral, it was a cool day in January. It started misting and I didn't have a hat. I caught a terrible flu or something. I thought about what my mother used to say: "Put something on your head. Put something on your head." And after that, I began wearing hats almost every day.

I realized right then and there, that even if I had

no hair, I'd glue a wig to my scalp

and put a hat on.

IRENE EGERTON

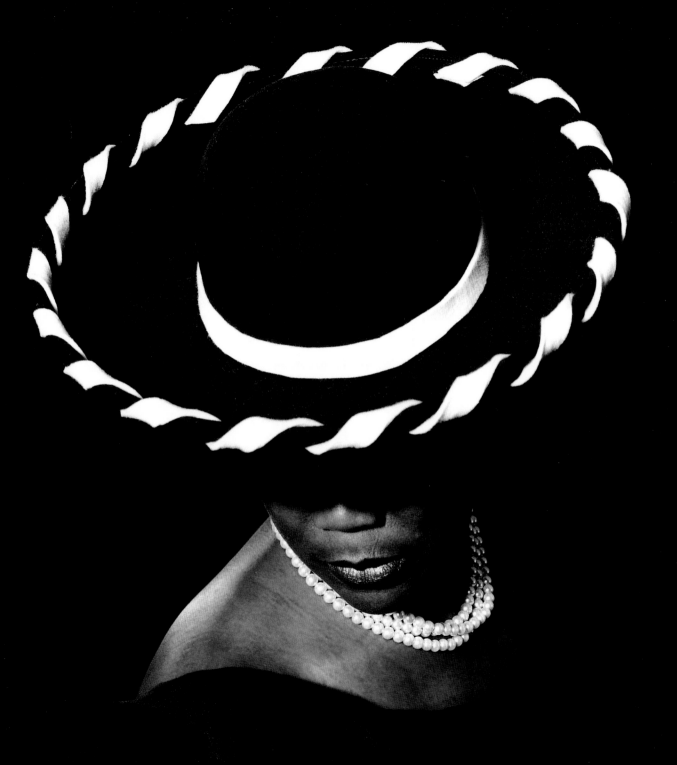

Irene Egerton, 44

JAZZ CLUB OWNER

*T*his is the only hat I have that will fit over braids. I discovered that when a friend invited me to church not long ago. I had been wearing my hair in braids for a few months and didn't want to take them out. So I pulled them back and hid them under the hat.

When I got to church, I felt so silly. I remember sitting there thinking, *Now, Irene, who are you fooling? People know you have braids in your hair under this hat. Who in their right mind wears a hat with braids?* I should have left it at home, but I couldn't imagine ever going to church without a hat.

I looked around the church self-consciously and this little old lady caught my eye. She made me think of the church I attended when I was a little girl. She had on a little gray wig and a hat. That's how the old ladies looked when I was a girl. You know, they had a hat, and a wig, then their hair under all that. That's a lot of layers.

Like I say, my mind went back to the Holy Trinity Pentecostal Church of God in Franklinton, North Carolina. My Aunt Bell was an evangelist there. There was preaching and sweating and shouting and speaking in tongues. There was always someone walking up to the altar to get saved, like some girl who later on might end up pregnant. They preached about a fear of God. If you don't do this and that, you're going to hell. We couldn't listen to the radio because it was devil music.

It was a small church that sat off a dirt road. Maybe had fifty members. In the summer, it was too hot inside the church to breathe. We fanned ourselves with programs or those hand fans with the piece of cardboard stapled to a stick. There was al-

ways a picture on one side of the fan, Dr. Martin Luther King or John F. Kennedy, and advertising for a funeral home on the other side.

The women wore long white dresses, down to the ankles, with sleeves down to the wrists, and collars up the neck. Back then, women had to hide their bodies and cover their heads to show respect for the house of God, so they wore white tams. Every single one of them.

The little girls had to wear white handkerchiefs on top of our heads. The handkerchiefs had pretty lace along the edges, which just barely touched our foreheads. They'd pin those scarves to our heads with black bobby pins and there'd be this black line of hairpins running down the handkerchief.

No matter how hot it was, you didn't take that handkerchief off your head. You just didn't dare. You'd see those white handkerchiefs flapping about like flags when the girls were fanning. The women never took their hats off, either. Not even the little old ladies with gray wigs.

So, the day I was in church with my friend, I thought to myself, *Okay, here I am with my braids up under my hat*. I realized, right then and there, that even if I had no hair, I'd glue a wig to my scalp and put a hat on. I thought back to my childhood and those little old ladies at the Holy Trinity Pentecostal Church of God. They'd also wear a hat regardless of what anybody thought.

I had become one of them.

You can flirt with a fan in your hand . . . You can

flirt holding a cigarette, too.

But a woman can really flirt with a hat.

DOLORES FOSTER

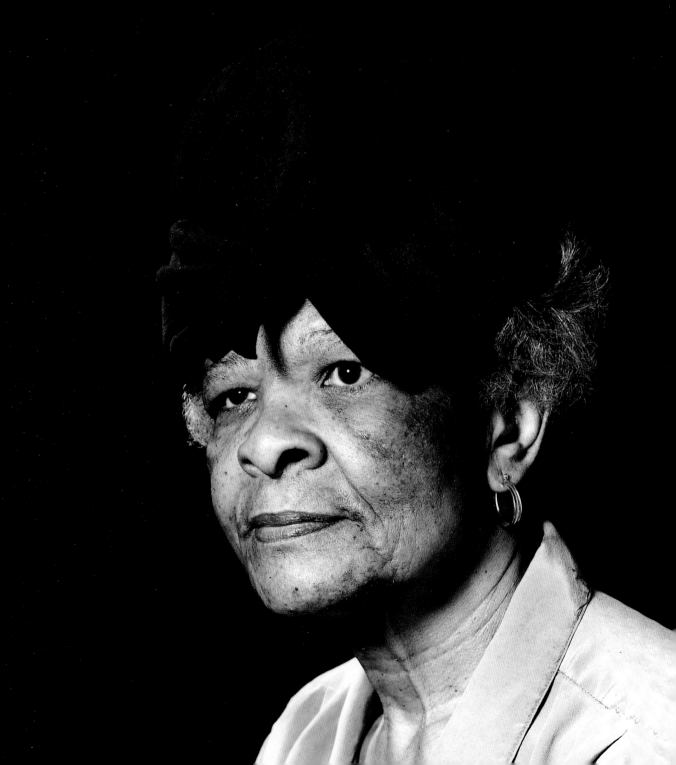

Dolores Foster ("A lady never tells her age")

REAL ESTATE AGENT (RETIRED)

was in the department store one day, just looking around, minding my own business. Now, I don't recall the dress I wore, but I had on a black straw hat with a floppy brim and a big flower on it. That hat has an air of mystery about it. Every time I wear it, I get compliments.

Well, this white gentleman was shopping, too. He knows he kept looking [at me]. Finally, he comes over and asks me, he says, "What do you think about this tie?"

I know he was just making conversation because that hat caught his eye. Catches a lot of men's eye. And I'm not out there looking for nothing. I'm just telling you like it is.

Men will tell you a thing or two about women in hats. A hat is intriguing. It's flirtatious. You can flirt with a fan in your hand, turn it this way and that. I don't smoke, never have smoked, but you can flirt holding a cigarette, too. But a woman can *really* flirt with a hat.

You have to have a certain feeling for a hat. Something just clicks. I like a hat with a little dash to it. When you see the right hat, you know right then and there that you're going to look good. You just *know* that you *know* that you *know*.

Sometimes I buy hats and don't even use them. Couple of hats, I've had them for

about twenty years and never had them on. Never once had them on. But I liked them in the store, it was a good buy, so I bought them. I'll wear those hats someday.

Listen, I don't borrow hats and I don't loan them out. No, no, no. If I loan out a hat, you can have it. I think I borrowed my mother's fur coat one time, but never her hats. When you buy a hat, it's yours. It's part of you.

I grew up in Linden, New Jersey. My sister and I always felt special because my mother sewed all of our clothes. Her designs were so different. Our dresses had pleats and tucks and embroidery.

When I was eight or nine, my mother went to night school to study millinery. That's what they used to call hat-making. Soon, my mother started making our hats.

She'd buy straw by the yard, wet it, weave and shape it, just like they do when they make baskets. She shaped the hats by using an old copper steamer with a long funnel. She also had a hat block, a piece of wood shaped like a woman's head. She'd put the straw over the hat block and hold them both over the steam funnel. She'd pull the straw this way and that until she got the style she wanted. The house smelled like wet brooms.

Once the straw dried, the hats showed their shape. Then, she'd trim them with ribbons or satin flowers. She had a knack for it. She taught me how to make hats, too. Seems like a lot of work, but we had nothing else to do. They hadn't invented TV.

o Pam . . . said, "My great aunt gave me a hat . . .

I think you might like it." I'm thinking,

"A little ol' white lady . . . is not gonna have the kind of hat I'd wear."

GAIL BERRY

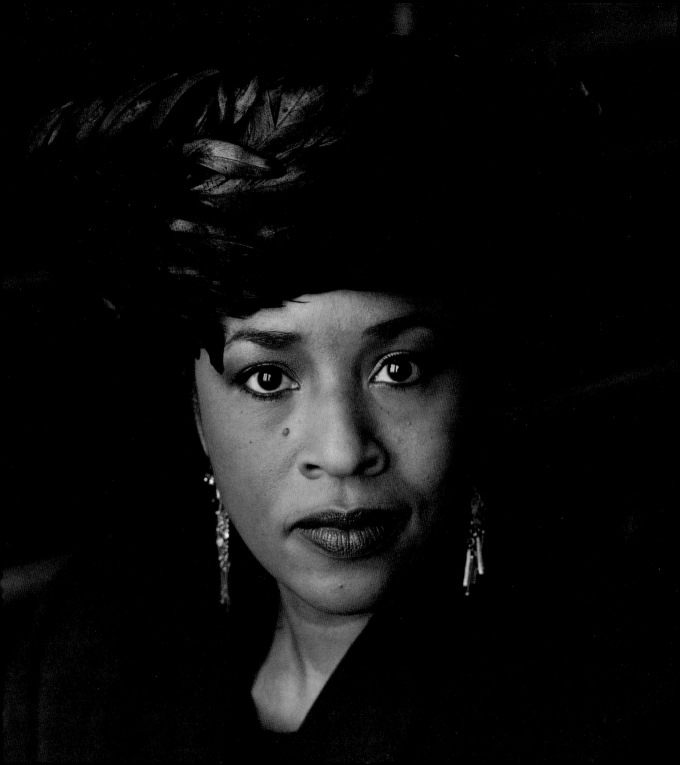

Gail Berry, 47

COSMETICS COUNTER MANAGER

You won't believe how I got this hat. Ten years ago, when I worked in the cosmetics department at Thalhimers, a white girl that worked with me came up to me one day. Pam was her name.

Pam said she had just visited a great aunt who lived in West Virginia or somewhere. Pam went up to help her clean out her closets. I think they were putting her in a rest home, and she needed to get rid of some old stuff.

So Pam came to me and said, "My great aunt gave me a hat, and you know I don't wear hats, but I think you might like it." So I'm thinking, *A little ol' white lady from West Virginia is not gonna have the kind of hat I'd wear*. But I said, "Well, just bring it. If I can't use it, I'll find someone who can."

The hat was in one of those old-fashioned hatboxes. [The box] had strawberry-red and white stripes with a beige, velvet-rope handle across the lid. The white stripes were on the dingy, aged side, but the box was still in good shape.

I took the lid off and saw nothing but tissue paper. I pulled the paper away and I saw what looked like peacock feathers, brilliant as jewels: emerald green, smooth and shiny. The hat sat on top of a stand that had a dome on top. The stand was attached to the bottom of the box. They just don't put hats in nice boxes like that anymore.

My eyes were glued to that hat. I lifted it from the box, carefully. Like I said, the box looked old, but the hat was in mint condition. That was a surprise because that hat had to be over twenty years old. Had to be.

When you looked at it from one angle, the feathers were a very dark green, almost black. From another angle, they were a lighter shade of green. The feathers shifted from shade to shade like gems. I was like, "Wow!" I couldn't believe it.

I tried the hat on right there at the Fashion Fair counter. But I already knew it was me. Pam was so excited. She looked at me and said, "I knew you could wear that hat!"

It's one of my absolute favorites. Definitely a treasure. In fact, I'd have to say that it's my very favorite because I couldn't replace it. I own about forty hats and I've shopped for hats all over the country, but I've not ever seen anything remotely like it anywhere.

A hat should say something more than "I'm covering your head." My motto for buying a hat is: "If I can't work it, don't wear it." This one has the feel, the look.

A couple of ladies in church have looked at that hat and said, "If you get to shoutin' hard and that hat comes off, it's *mine*." Some of them have even asked to wear it, but I'd lend my children before I'd lend my hats. I know my children know their way home, but my hats might not.

Who'd have thought? I mean, a little ol' white lady from West Virginia. Thanks, wherever you are.

The netting decoration on the side [of this hat] is metallic, and it can hurt you good . . . Who needs karate?

JEANNETTE LEWIS

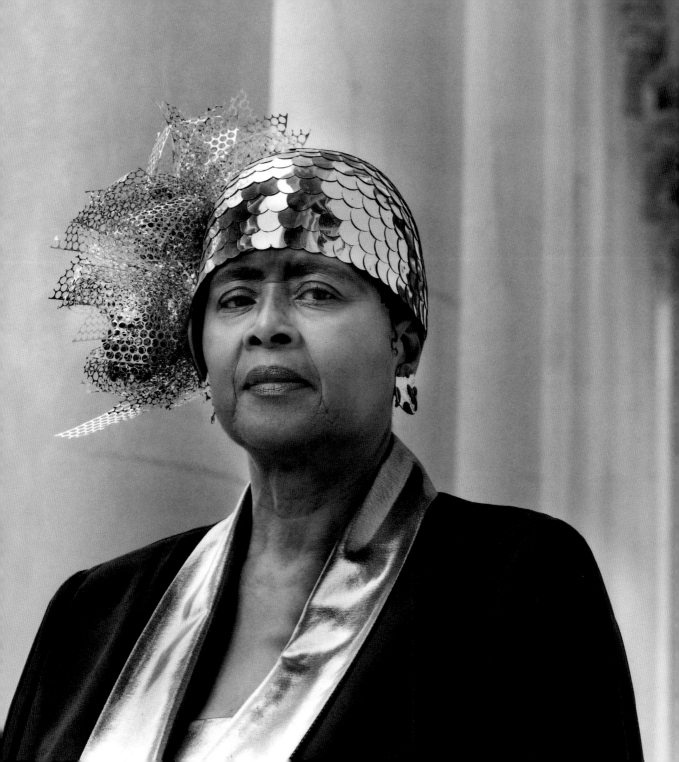

Jeannette Lewis ("Old enough to be retired")

MIDDLE SCHOOL TEACHER (RETIRED)

A young black man in Baltimore made this hat. One day, I walked up to his booth at a trade show and he was making hats on the spot. He was gluing the gold sequins on the shell. I needed a hat to go with a dress of mine, which also has gold sequins on it, only smaller. So when I saw the hat in his hands, I said, "That's it!"

This hat gets all kinds of compliments. Somebody once told me, "Girl, you really make a statement with that hat." There's only one downside: The netting decoration on the side is metallic, and it can hurt you good.

I had this hat for years before it hurt somebody. One time, my friend Johnetta was so glad to see me. She had moved to California and I hadn't seen her at church in a long time. We were in the lobby after church and she came running. "Oh, there's Jeannette!" And I said, "Oh, there's Johnetta!" And she hugged me from the netting side and it scratched her near her eye. She said it just scratched her a little bit, but I felt so bad.

After that incident, I said I'd have to give this hat a nickname: the Gold Dagger. They could use it in one of those James Bond movies. Maybe I ought to wear this hat when I'm alone at night. Who needs karate? You know, if you were greeting someone you didn't like, the netting would be a good weapon. But that's awful. I shouldn't say that.

One time, I even had to warn my pastor to be careful. I've got a hugging pastor.

He came up to hug me after church and I told him, "Pastor, if you hug me on that side you could get hurt. That netting might scratch you." He said he wasn't scared of my pretty hat and gave me a big hug to prove it.

Women today just don't wear hats like they used to. I've heard all kinds of reasons for it. Some say hats are too hot. Some say hats make their head itch. Some say they're too heavy. Some say hats mess up their hairdo. But I love them so. I'm going to wear a hat 'til the day I die, and then I might even be buried in one.

Times are getting too casual. There was a time when you could walk in a school and tell the teachers from the students. But now they're *all* in jeans.

Same thing with church. Some women have gone from not wearing hats in church to wearing pants. Who knows what's next? Pajamas? I just believe in sticking with some good old-fashioned values. You know, in England, women wear hats all the time; the royals *and* the regular folk.

Guess I'm not helping things with this dangerous hat of mine. I might have to wear a little sign saying, "Beware! This hat could be hazardous to your health."

ou buy [a hat], you wear it, but then you wonder if it

really fits your face.

BETTY NELUMS

irl you wearing *that hat.*" That's the talk we talk.

GLORIA SWINDELL

ve had someone tell me, "Girl, I'll throw you down for that hat."

WANDELLA RIDGILL

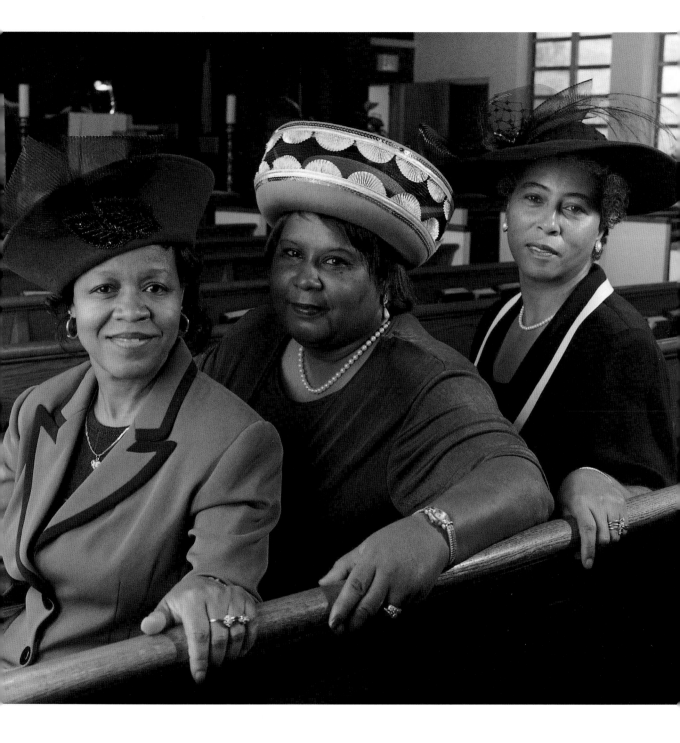

Betty Nelums (l), 46

DAY CARE CENTER OWNER

The thing about a hat is that you see it, you buy it, you wear it—but then you wonder if it really fits your face. So when you go to church, you say to your friend, "I got this hat but I'm not sure if it's quite right." Then they'll start tilting it for you and say, "Maybe you need to bring it to the front or take it a little to the back." We call that working with it. I guess that we, as black women, know what a hat should be doing. And we feel comfortable when someone else works with it. Women are the world's best at dressing each other.

One Sunday, I even had this older lady come up and fix the veil on my hat. She said, "I would like *this* better." And she took the veil and pushed it up under the brim. You could still see the veil, but it wasn't hanging down. I thanked her because I knew she got me perfect. And now, when I wear a hat with a veil on it, I just tuck it under.

Gloria Swindell, 45

HEALTH CARE SPECIALIST

In some cases, I think hats become competitive. Like if we're going to a workshop or a convention or something, I'll say, "Girl, what hat are you going to take?" Someone else might say, "What color are you wearing?" And if I say I'm wearing blue, then I don't look for Betty or Wandella to wear a blue dress or a blue hat. They'll

probably wear white or some other color to let it be known that everybody is in the house.

But I find that women who love hats don't come to a point where they get jealous. It makes you happy to see a hat that looks good on someone. "Girl, you *wearing* that hat." Or, "You go on with yo bad self." That's the talk we talk.

Wandella Ridgill (r), 49

NURSING HOME ACTIVITIES MANAGER

I've even had someone tell me, "Girl, I'll throw you down for that hat." One Sunday, I was going up the steps to the balcony and this lady was behind me. She was a visitor. She said, "Oh, I just love that hat!" There was a real sincerity in her compliment.

That was the first time I wore that hat. I had just bought it in Charleston. It was white and had a mixture of cloth and straw. It had a wide brim and didn't stand up real high. And it had a curly white feather. A real pretty hat.

That lady didn't have a hat on, so I took it off and said, "Here, try it on." She said, "No, no." I said, "Go ahead." So she put it on as we walked to our seats. Someone said to her, "Honey, that hat looks good on you."

When we sat down, she gave the hat back. I put it on my lap until church was over. Then I told her, "Here, you can have it." She said, "Oh, no!" I said, "Oh, yes! The Lord is telling me to give it away. Don't take my blessing from me." Then she said, "The Lord is good." The next week my son bought me two hats, not knowing anything about the one I gave away. Give and you shall receive.

ut on a church hat [and] I had instant class,

a bunch of class.

OLUFEMI ELOM

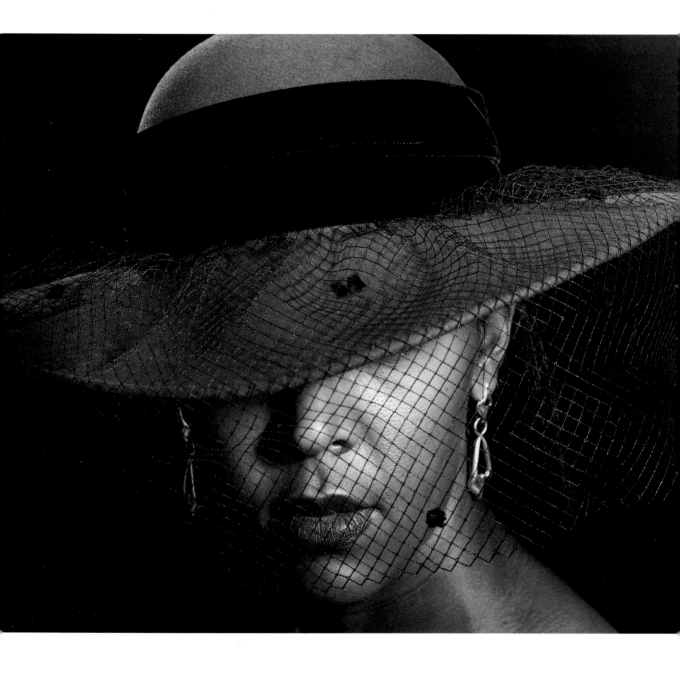

Olufemi Elom, 36

FASHION DESIGNER

*I*n Brooklyn, New York—that's where I grew up, in Brooklyn—you could be an individual there. You could dress like you wanted, without people looking at you strange. When I was a freshman in high school, I'd design and sew my own outfits and make a hat to match. Mainly, I wore those baggy diaper pants, some people call them M.C. Hammer pants, and a fez or African headwrap or some other kind of hat.

I loved my hats. I had a gangsta brim, a court jester hat. You name it. If I put on a derby, I was a homey, a Brooklynite hanging with the guys. If I put on a fez or a head-wrap, I commanded respect. Put on a church hat, I had instant class, a bunch of class. It was a lot of fun.

But in 1979, when I was fifteen going on sixteen, my mother sent me to live with my grandmother in Youngstown, Ohio. I came to a new high school, North High, with a very unique style. The reaction I got shocked me.

On my first day, I was walking through the hallway and I had to pass what looked like the whole football team. They started laughing at me. I can't remember what I had on, but it was one of my usual unique hats and outfits.

Everybody thought I was crazy. They said, "We don't wear those kinds of things here." All they wore was jeans, khakis, and T-shirts. A lot of people thought I was a voodoo woman or a witch or something. It upset me a lot.

Some of the teasing might have been my fault. It didn't help that I was from New

York. New Yorkers aren't real friendly to strangers, you know, and this town was use to people being friendly. So I always stood out. I was the outsider.

There was this one girl who would follow me up and down the hallways, and everything I would say, she would say behind me. If I said, "You again?" She'd say, "You again?" If I said, "What's wrong with you?" She'd say, "What's wrong with you?" "Back off!" "Back off!"

I took it for a whole year. I was going nuts. But then I just got *more* outrageous. Once, I took a baseball cap and I attached a fake-fur tail to the back. The football guys called me Beaver.

I guess I dressed like that for the shock value. But it was also an effort to be myself. I chose to look that way, and that gave me a sense of power.

One day, I walked right up to some guys on the football team and stuck my finger in their faces. I said, "Why are you teasing me? I don't even know you. I've had worse than this little bit of teasing. I'm not going to crack." They backed off after that.

Now when I go back to visit I always step into Youngstown with a nice hat, clean as a tack. It's my way of saying, "You tried to make me change, but I'm still me."

I guess that was my first love affair with hats, just playing church with my brother and sisters, pretending to be Mrs. Mary.

HATTIE INGRAM

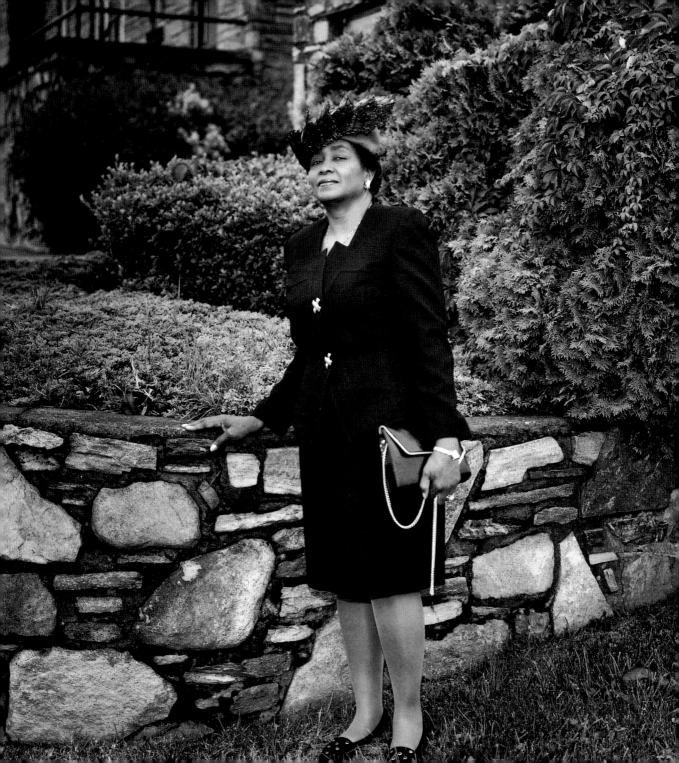

Hattie Ingram, 65

ELEMENTARY SCHOOL TEACHER (RETIRED)

When I was approximately eight or nine, Mrs. Mary was one of my favorite persons. She always sat near the front of our church. Every Sunday, she wore a new dress and hat, which my mother made for her. Mrs. Mary loved to sing. Right before the sermon or right afterward, she'd get up and sing. No one asked her to sing, she just sang. She would always walk straight across the front of the church singing, back and forth, back and forth, like she was on stage, throwing up her arms for emphasis.

Mrs. Mary had a beautiful voice. She'd get the church all in an uproar with her songs. Not only did she sound so nice, she also looked so nice in her new hats and dresses. I wanted to be like Mrs. Mary.

Mrs. Mary came to our house every Monday. She'd bring new fabric for my mother to make her a new dress. With Mrs. Mary, there was no pretense. She'd say, "How did I do on Sunday? How did I look? Wait 'til you hear my song *this* Sunday." And she'd say to my mother, "I want you to make this dress lay down on me just like that one did last week." Mrs. Mary considered herself to have a pretty good figure, and she wanted her dresses to fit snugly.

She was a short little person and heavy on the bottom. Kids always think grown-ups are really old, but I think she was about fifty. I remember distinctly Mrs. Mary used to say to my mother, "I want you to make me look good so I can strut my stuff." Then Mrs. Mary would show us how she was going to perform on Sunday.

My mother was a busy seamstress. She made dresses and hats for a lot of the women in our church. She might have charged three dollars and a half to make a dress. In the summertime, it was not unusual for her to make twelve to fifteen hats and dresses in a day. My sisters and I would hem the dresses and sew on the buttons and so on. I also learned how to put straw on the hat forms, and add a little bow or a flower. Those ladies at our church loved dresses and hats, especially Mrs. Mary.

My mother never sewed on Mondays. That was her shopping day. She'd go buy supplies and straw to match the color of the dresses she was making. While she was shopping, we had a good time playing church.

My brother, James, was always the preacher. He thought a boy could be a preacher and my sisters and I could not. We had a player piano in the living room. We'd put a roller of church music in the piano and my sister Mildred would pretend to play, but all she had to do was mash the pedals to keep the piano going. My middle sister, Mary, would sing.

We would wear some of my mother's hats or the hats she was making at the time. We'd listen to James preach, we'd sing and shout, we'd strut our stuff around the house with those hats on. I guess that was my first love affair with hats, just playing church with my brother and sisters, pretending to be Mrs. Mary.

almost lost this hat when I was preaching the Women's Day service. . .I went one way across the pulpit and the hat went the other.

SHIRLEY GAITHER

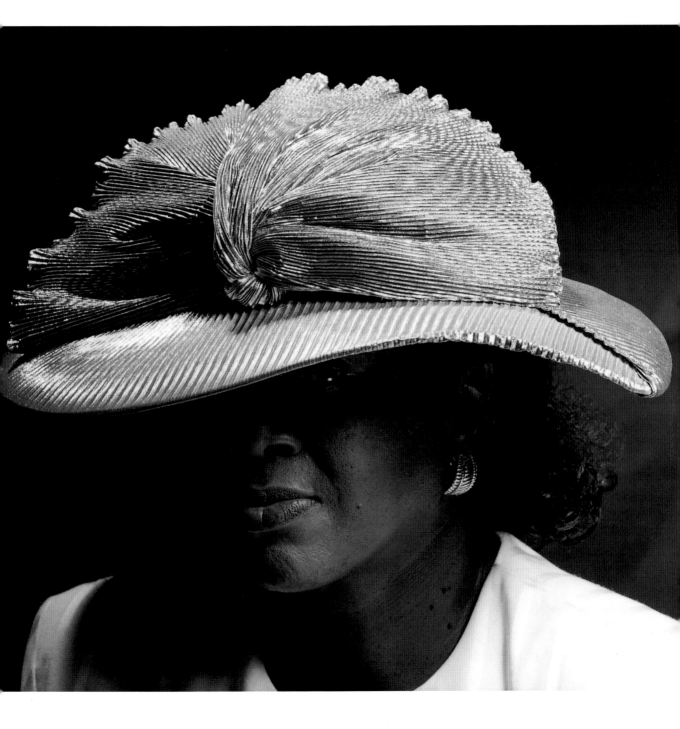

Shirley Gaither, 54

EVANGELIST AND PASTOR'S WIFE

I got this hat at a friend's yard sale for ten dollars. She had paid eighty-five dollars for it. I almost lost this hat when I was preaching the Women's Day service at the Middle Fork Christian Church.

The title of my sermon was "Run and Tell That." It was about when Jesus met the woman at the well. I said that we women sometimes talk too much, but the things we need to tell, we don't tell.

When Jesus told that woman everything she had done, the Bible says she ran back into the city. And I said, "We run and tell everything we shouldn't tell, but how many of us will run and tell our neighbors the truth? Run and tell them they need to be saved? Run and tell them that God can set them free?"

The Spirit was movin' in that place. In holiness churches, we don't just sit around all quiet. We know how to make some noise. I've been a pastor's wife for twenty-three years and I'm not ashamed to have a good time in the Lord. And when I said, "You need to *run*," I went to demonstrate how we should run, and that's when I went one way across the pulpit and the hat went the other.

My hats crawl off 'bout every Sunday. It's no way to hook 'em on. One of the members will just pick it up and hold it until I sit down. When you get into the praise and worship service, and the Spirit hits you, you forget about how sharp you think you are. That ain't what it's about no way.

Basically, I say that you shouldn't have anything that's more important than prais-

ing the Lord. I've never had a hat, no matter what it cost me, eighty-five or a hundred dollars, that I said, "I'm not going to shout today because I have on my pretty hat." I'd never let materialistic things like a hat be more important than getting my praise on, as the young people would say.

When I was getting ready to leave the church, I realized I didn't have my hat. When I went back for it, one church mother said, "I was hoping you wouldn't come back. I was going to keep this hat."

I wear hats every Sunday because I want to set an example. The Bible says, "Women, adorn yourselves in modest apparel." As the first lady of the church, if I came in there in dresses with splits all the way up my leg, then I couldn't ever tell the young women that this or that is not appropriate.

Sometimes, for example, women will wear those short skirts to church. If they sit on the front row, I tell the nurse to go put a scarf over their legs. I mean, my husband's up there trying to preach and some woman's sitting on the front row with the gates of hell wide open. I feel like telling some of these women, "You better leave me alone because you don't know what I got delivered from. I might look all refined in my pretty hat, but I might have just been delivered from using a hawk blade knife."

When Daddy caught sight of me in this hat, he burst
into the biggest smile.

VELMA FIELDS

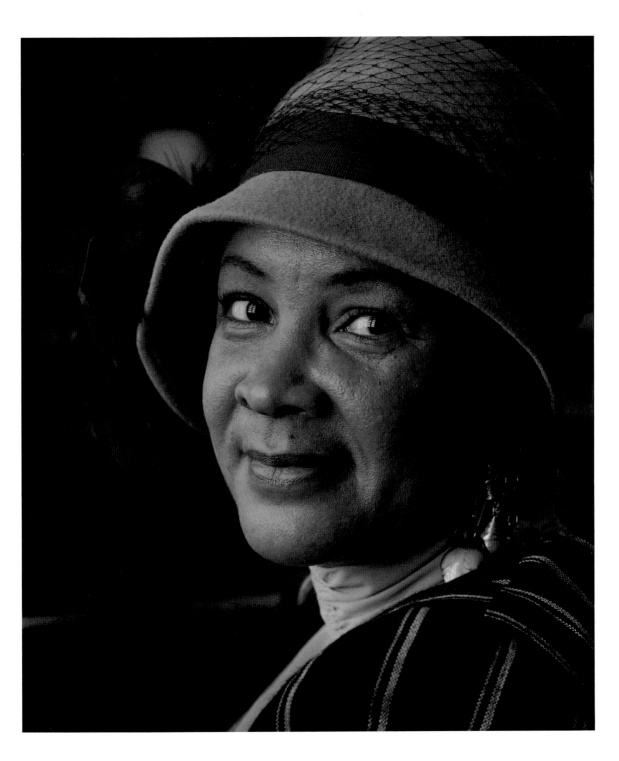

Velma Fields, 54

Registered nurse

When I bought this old-timey hat, I knew Daddy was going to love it or he was going to hate it. I wasn't sure. I remember the first time he saw it. That was on a Sunday about ten years ago. He would have been seventy-four years old back then.

I always went to see Daddy and Ma every Sunday after church. I admit to being a Daddy's girl. I have eight brothers and sisters, and Daddy loved us all, but he and I had a special bond. Anyway, I went to see him that Sunday and when Daddy caught sight of me in this hat, he burst into the biggest smile. Then he started laughing.

I said to him, "What's the matter, Daddy?" I wasn't sure if he was picking at me. I said, "Do you like it or not?"

"Yeah, Velma," he said to me, "I like that hat. Your mother used to have a hat like that. You look just like your mother. Just like your mother."

Daddy said the hat reminded him of the roaring twenties and thirties. He liked to talk about those times. That's when he and Ma had met as teenagers. They both were members of the same church.

Back in that day, young people weren't allowed to date. So Daddy said he had to sneak around to try and see her. And the hat just brought all those memories back, 'cause Ma had one just like it.

He was a hat man himself, Daddy was. He wouldn't step out the door without a hat on his head, one of those fedoras. Wore them all the time. It might be why he was bald-headed.

Every time I wore this hat, Daddy would burst out in the biggest smile. In fact, I had to take a picture in that hat and give it to him. He framed it and put it on his dresser.

About four or five years after I bought the hat, Daddy got real sick. It was cancer. He was in and out of the hospital for a year. It was a hard time. Daddy was such a good man, would do anything for his family. And I wanted to do everything I could to make him happy. One of the things I did was to wear the hat when I went to visit.

He'd always say, "You look just like your mother in that hat. Just like your mother." If ever I showed up wearing a different hat, he'd say, "Now, Velma, when are you going to wear my hat again?"

Daddy wanted to make it to his eightienth birthday, which was on October 27th. He made it. He was so proud of that. He died that December, almost a year after he got sick. After he died, I wrote a little poem:

> *I lost my dad this past year,*
> *And when he passed, I shed a tear.*
> *You know, I always was a Daddy's girl,*
> *And I did what I could while he was in this world.*

Daddy died four years ago. I still think of him every time I put this hat on. I do let friends borrow my hats, but not this one. This is Daddy's hat.

When it comes to hat wearing, I'm a late bloomer.

JUANITA WILLIAMS

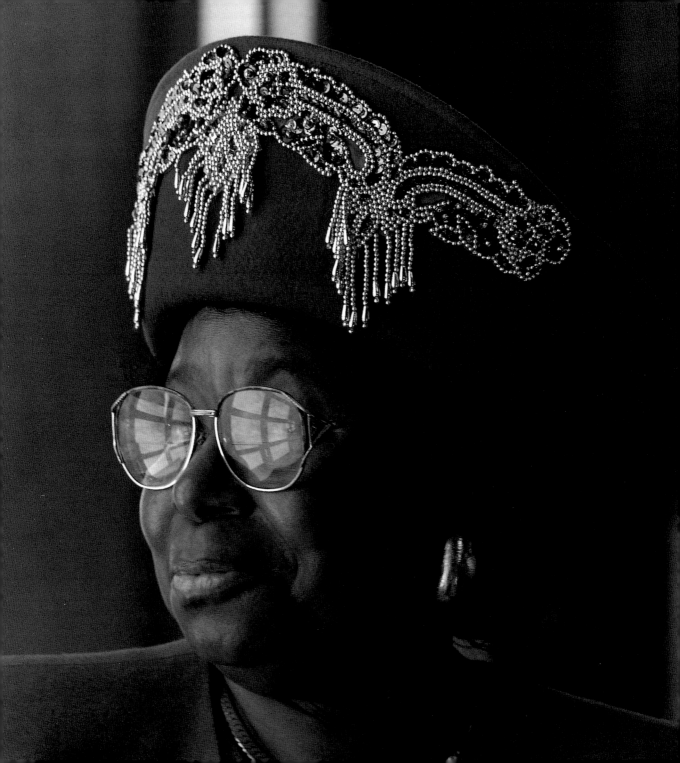

Juanita Williams, 61

DAY CARE TEACHER

When it comes to hat wearing, I'm a late bloomer. For about thirty years, I only had two hats: a black hat and a white hat. They were my pulpit hats. The elders said a woman was supposed to cover her head when she was in the pulpit. I only wore my pulpit hats maybe once or twice the year since I didn't go into the pulpit that often. But three years ago, I started buying a bunch of hats. Now I have about forty, in every color.

Even when I was coming up as a little child, I wasn't fond of a hat. But my mother wore hats to church every Sunday. I could never understand why, because when she got to church she'd take the hat off and put on her white choir robe. When church was over, Mother would take off her robe and put her hat back on before we went home. I couldn't see the purpose of wearing a hat just to walk to church and back. But she did.

I tell you the reason I wasn't really fond of hats. When I was coming up, I was always around a lot of boys. I had three brothers. And there was a lot of boys in the neighborhood. And the girls in the neighborhood was just as rough as the boys. We used to play ball and climb trees. We was not feminine and dainty. So I didn't like hats and dresses.

One day, when I was around eleven, we were going to a church meeting. My mother put me in a yellow dress. It had a band around the waist with a bow in the back.

Had me lookin' nice. I was supposed to sit down and stay clean until Mother got dressed. But the boys were playing in the woods back behind the house.

There were all kinds of trees back there: good, stout oak trees, apple trees, peach trees. And there were some trees that were covered with grapevines.

We'd swing from the tree branches, jump down, climb back up. We'd tie a rope up there and swing like Tarzan. That day I had on my yellow dress I decided I was going to swing in the trees with my friends. I tore my dress band climbing up.

When Mother came outside, I walked up to her with my head down, trying to hold that band together. She said, "Neet, you gonna get a whuppin'. You know better than to go out there and climb that tree." Oh, I got a sermon that day. I got a whuppin', too. Then I got another sermon after the whuppin'.

Mother passed October 3, 1976. Back in the day, she was always trying to teach me to be more feminine. I think she would be happy to know I wear hats now. But her happiest moment would be knowing that I'm still in church. My mother told me, "Whatever you do, find time to serve God." I never have forgotten that.

efore we left for the party, my mother said

we looked adorable. I said,

"Adorable ain't what we're shooting for."

DAPHNE JOHNSON

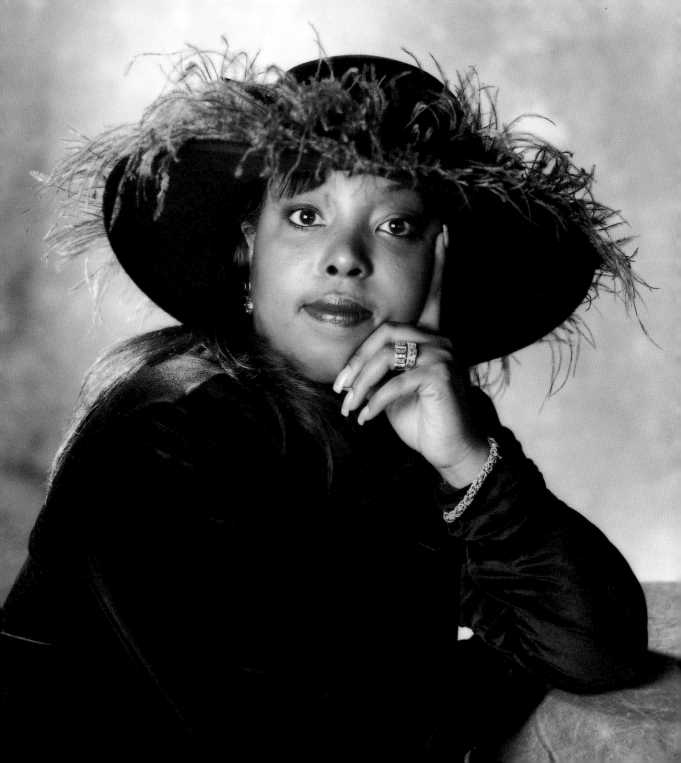

Daphne Johnson, 43

FREELANCE WRITER

Two of my closest friends and I started a hat trend in Macon, Georgia, when we were eighteen. That was back in 1974. My first cousin Derrah and her friend Pam lived in New York and they'd always come down to Macon to visit me. This particular summer, I was a contestant in the Miss Black Macon pageant. There was a big dance that Saturday. All these people from Atlanta were coming down to Macon. It was big.

We wanted to wear something special, so we put on those Danskin bodysuits that were so popular back in the day. Our pants and tops were navy blue. When we looked at ourselves, we thought we looked boring—*everybody* would be wearing bodysuits and pants.

Pam said, "Nobody will be wearing hats!" She had brought three straw hats with her that belonged to her older sister. Those hats were the rage in New York. When I saw them, I had second thoughts. They were made of colored straw: the blue, the red, and all of that, and they were finely woven. The hats had round tops and wide brims. The thing was, my grandmother used to wear one just like it as a garden hat. She tied hers under the chin. I kept seeing the picture of Big Mother in her garden hat.

But then, we put some sheer, navy blue scarves around the crowns and tied them in the back. I thought, *Okay, at least we're not tying them under the chin.* The more we looked at ourselves, the more we thought we were just too fly and so different. Before we left for the party, my mother said we looked adorable. I said, "Adorable ain't what we're shooting for."

So we go to the dance, and, of course, no one else has on hats. Yeah, we created a ruckus. One guy, who was from New York, cracked on us. He said, "I've never seen real Southern belles before." I said, "This is a New York thing and I don't think New York is in the South." Another guy took up for us. He said, "Women who wear hats know who they are."

At about one o'clock, we went to a restaurant called Krystal's, which was the hangout place for blacks after a party. This crazy-looking guy was sitting right at the end of the long chrome counter. He hit on us as we walked by, "Hey, what's y'all names?" We rolled our eyes and hurried to a table.

Derrah had to go to the bathroom and the crazy guy followed her. She told him she was with someone. When Derrah got back, Pam went to the bathroom and he followed her. She also told him she was with someone. When Pam got back, I said, "Forget that. I'm going to hold it." We started laughing. Then I said, "You all told him you were with someone and there's not a guy at this table. He's going to think we're with each other, if you know what I mean."

We laughed so hard that we bumped heads. Our hats fell off and then we *really* lost it. One minute we were making a fashion statement; the next minute we were totally embarrassed.

Not long after that night, girls in Macon starting wearing straw hats. To this day, we still take credit for it.

I was twelve when I first saw church women in fashionable hats. I said, "Oh, I got to do this!"

SANDRA WRIGHT WALLINGTON

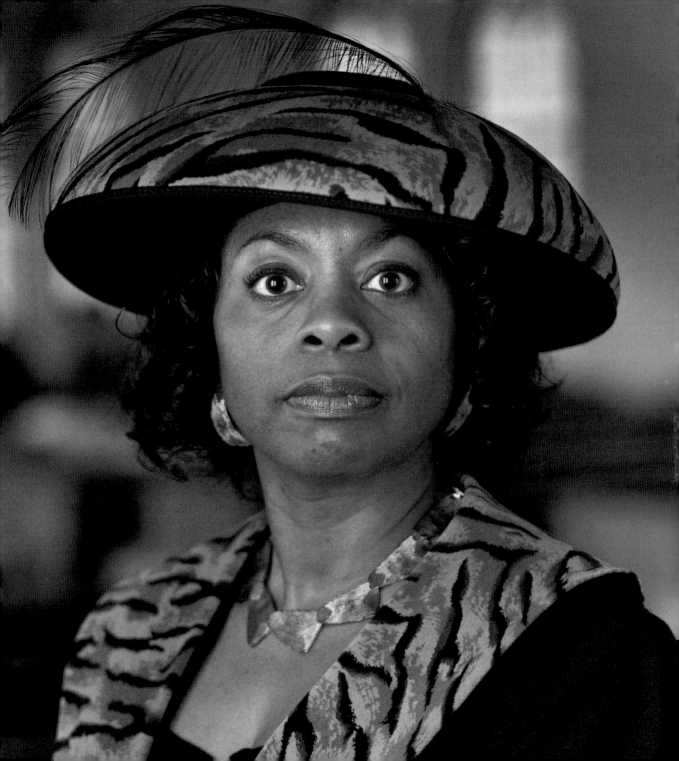

Sandra Wright Wallington, 49

Human resources manager

My daddy's a retired United Methodist minister. When my brother and I were kids, Daddy was a part-time minister, and part-time ministers got the smaller, rural churches. He'd preach at one church one Sunday and another church the next Sunday.

Some of the women in those churches wore hats, but they weren't extraordinary. No brim, no ornamentation, no statement. Just head coverings, for the most part. They were good people, but they were rural America, simple people.

I can remember the first time I noticed fashionable hats. It was at a Baptist church, Shiloh Baptist. I was twelve and Mom and Daddy had allowed me to go to church with a friend named Jackie, who was also twelve. That was a big thing. My daddy really struggled with that. I don't think he was concerned about the different denomination. He was just strict. He liked me under his watchful eye.

For example, I was fifteen before I could take company. Daddy let me take company Sunday evenings from seven to nine—with me and the boy and the *whole* family in the living room. I remember very well that *Bonanza* came on at nine, and that was the time the boy was supposed to leave. My family took a break right before *Bonanza*; they would go to the kitchen and get ice cream or whatever. If the boy wasn't gone before they came back to the living room, my daddy would say, "Sandra, do you not know how to excuse your company?" Right there in front of him. Daddy was very, very strict. So you see why it was a big step when he allowed me to go to church with Jackie.

It was my first time going to a big, urban church. Jackie had a hat on but I didn't. As we walked in, I noticed lots and lots of hats. All ages were wearing them, from teenagers to the elderly women. And they weren't plain hats. You had the wide brims, you had the feathers, you had the rhinestones, you had the netting. At that age, I didn't get into the service the way I do now, so it wasn't very hard for me to be distracted. I said, "Oh, these hats are *bad*! They're really bad. I *got* to do this."

When I got home, my family was eager to hear about my day. My dad said, "How was the service? What was different?" I'm sure they were surprised to hear what I was most impressed by wasn't the sermon. I said, "Mom, the women looked so beautiful."

I was able to point out some differences in the service: The congregation was more responsive to the minister, not quiet like in our church; they sang lively spirituals and gospels, not hymns. But I was most taken by the women and the way they dressed. Daddy shook his head.

I immediately started on my mom about the hats. Her position was that I was a bit young. The next time I went to church with Jackie, which was later that same year, I wore a hat. I borrowed it from Jackie. If I remember correctly, it was a black hat. It was the pillbox style that Jackie Kennedy made so popular around that time. My parents never knew.

At that age, it's important to feel like you belong. I'm sure that those women at Shiloh never knew the impact they had on a twelve-year-old girl.

I think adorning the head is a retention of African

traditions . . . Hats are a part of us.

DELORES SMITH

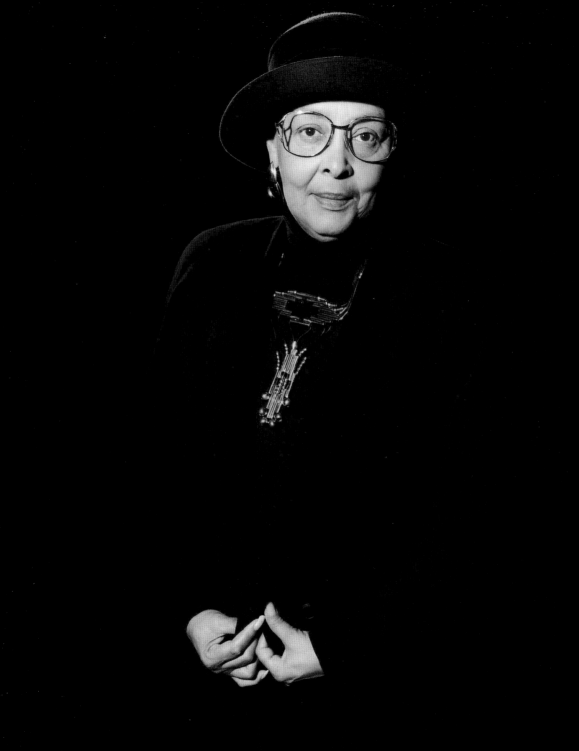

Delores Smith, 59

President of Urban League chapter

I've always worn something on my head or in my hair. From the time I was a little girl in Youngstown, Ohio, my mother decorated my hair with ribbons from funeral wreaths. My mother was a housemaid. For twenty years she worked for a family who owned a funeral home. She spent more time with that family, trying to make a living for us, than she spent with her own family: six days a week; only Sundays off.

Well, my mother would bring home wreath ribbons in all different colors. She would untangle them and wash them and starch them and cut them, and that's what I wore in my hair.

My mother always had something on her head, too. She wore turbans, but of course, we didn't call them turbans at that time. They were colorful scarves, never drab, a big piece of fabric that you would fold into a triangle and put over your head. But my mother did hers differently: She would wrap it around her head in a creative way to get a unique style. Fact is, she was wearing African-inspired headwraps long before they were popular.

I don't believe my mother wore the turbans because of a cultural identity. It was just part of her work uniform. It was a way of not having to fuss over her hair. She didn't have the time.

Now, I must say to you, that because I didn't know at my young age to appreciate her headwraps, I called them head rags. "My mother's always wearing head *rags*." I

was embarrassed by them. My mother came to my school so much because of my misbehavior that they almost thought she worked there. When she came, she was always clean and neat, but she always had on one of those head rags. I never let her know that I was embarrassed. I didn't want to hurt her. I would just swallow.

The kids never teased me about her head rags. My mother was so pretty that her beauty was appreciated more by my schoolmates than it was by me. It was simply my own lack of appreciation for her unique style.

The first time I remember seeing my mother without that head rag was when I was about eighteen. I left home after I graduated from high school, went to New York, and got a job. When I came back home, my mother did not have a head rag on. I said, "Wow, I didn't know you had hair!" It was the first time I ever saw her hair. It was beautiful: long, a brownish-black, and soft, so soft until it wouldn't keep a curl. She had changed jobs. She became part of the janitorial team for the school system, and had no need for her head rag.

As I look back, my mother's headwraps were very becoming and very artistic. They were also true to our African heritage, even if she didn't recognize the link. Now *I'm embarrassed* that I was embarrassed.

I think adorning the head is a retention of African traditions, although we've modernized it to some extent. You will not find white women wearing the same boldly adorned hats that black women wear. Hats are a part of us.

I asked my mom what she thought about me wearing this hat to Grandma's funeral, because it is a whole lot of hat.

DEIRDRE GUION

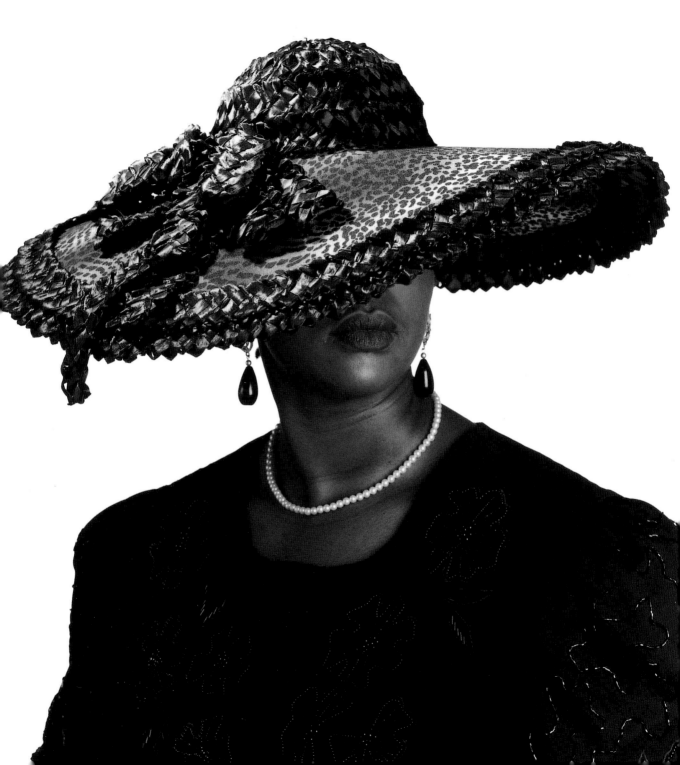

Deirdre Guion, 35

OWNER OF A PUBLIC RELATIONS COMPANY

I think this hat is reminiscent of the Mae West era. A friend of mine made it. She's a milliner in Memphis. It's very striking, but it's also a very fine hat. When Chris gave it to me, she said, "Most women would not only be afraid of a hat like this, they wouldn't appreciate the details."

I've only bought one or two hats in department stores. I prefer the finer ones in boutiques or from milliners because there's such a big difference in quality: The seams match up, the hat is lined and blocked to fit—not like the one-size-fits-all hats you buy off the rack. Handmade hats are more expensive, about three or four hundred dollars, but you get what you pay for.

The first time I wore this hat was for my grandmother's funeral in New Orleans. I loved my Grandma. As she got older and became ill, I would do her nails, put on her lipstick. I would fuss over her to make sure she looked the way I knew she wanted to look.

I asked my mom what she thought about me wearing this hat to Grandma's funeral, because it *is* a whole lot of hat. She said, "I think it's too fussy." One of my aunts came to my defense. Auntie Henny is also my godmother, so I call her Nanny. Nanny said, "Well, Deirdre fussed over her grandmother, so I think a fussy hat is completely appropriate." So I wore it.

When we reached the cemetery, an elderly man, who was one of the limo drivers, dashed to open my door. He had to be every bit of eighty years old, but he ran to that

door to help me. He gave me his hand and said, "I always help a lady with a hat first." My mom was in the car, and other older women, but he wasn't worried about age or anything else except helping the lady in the hat. It was like a throwback to the days of chivalry.

A lot of women can plop a hat on their head, but they can't carry it off unless they have the attitude to go with it. That's what I call "hattitude." Hattitude is something you have to possess in order to wear a hat well.

Every hat is not for every woman. For starters, a hat's height should be proportionate to your body. If half of you looks like hat, I'd say that's a problem. You shouldn't wear a hat wider than your shoulders. Elongated or oval faces look better with wide brims. Rounder faces look better in the derby style: shorter brims with rolled tops. Your hat shouldn't be darker than your shoes. Personally, I think sequins and glitter aren't appropriate for daytime or for church. Hats should be simply decorated. Some women think the more stuff you can fit on your head the better, and I've seen hats that look like lamp shades with tropical fruit and birds and ringing bells hanging off them.

There's a little more strut in your carriage when you wear a nice hat. There's something special about you. I think people detect that, which is why that limo driver wanted to help the lady in the hat first.

cried, "I don't want to go to church without my hat.

They won't look at me."

DOROTHY GRAHAM-WHEELER

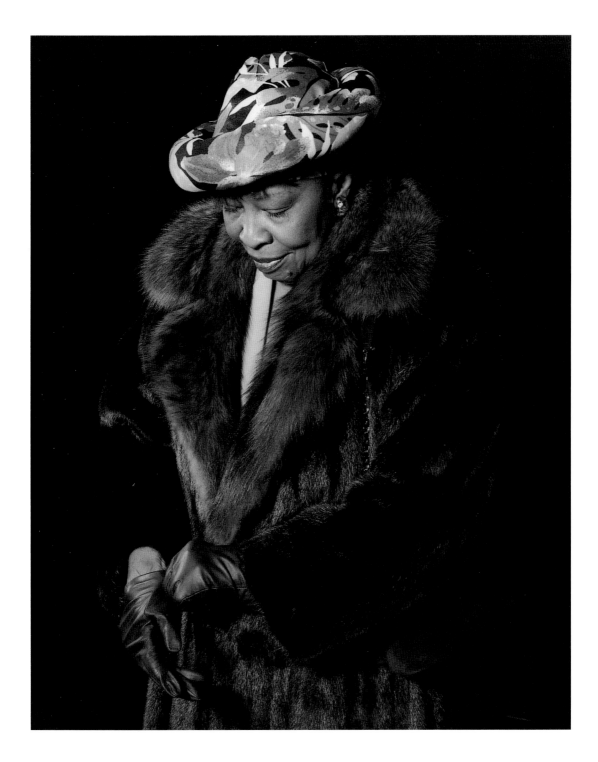

Dorothy Graham-Wheeler, 68

DIRECTOR OF A CHILDREN'S DRUG-PREVENTION PROGRAM

*G*uess you can call me a hat freak. I have a couple of hundred hats, stuffed in five closets. Some women only wear hats on Sunday; I wear hats *every day*. We were poor, growing up. For a long time, I only had one hat. I think that's why I'm so obsessed with buying them.

When I was a little girl, probably about seven, my mother bought me my first Easter bonnet. It was made of white straw with dainty, pink roses around the brim. And then it had a pink band tied in a bow and a streamer in the back. Mom got me a cute little pink dress to match. I liked the dress, but I *loved* the hat.

When I got to church that Easter, the grown-ups would say, "Dorothy, that hat looks so pretty on you." And, "Dorothy, you look so cute." I just smiled, put one hand on my hat and the other on my hip, and kind of turned and modeled. Then, some little boys started looking at me, like they wanted to say something but couldn't. All the other girls had on Easter bonnets, too, but I felt like the prettiest of them all.

The other little girls didn't wear their bonnets after Easter, but I wore mine every Sunday for weeks and weeks. It was the first time I had got that much attention, and I liked it. Two of my brothers, Joseph and Chico, would say, "That silly ol' hat. That ol' ugly hat."

One time, they snatched my hat on our way to Sunday school and ran with it. I

screamed. Mom yelled, "Come on back here with that hat." They dropped it and mussed it up: The ribbon tore and the bow fell off. I was crushed.

That next Sunday, my mother braided my two sisters' hair and put ribbons and combs in their hair, like always. Then she looked at me and said, "You're next." I cried, "I don't want to go to church without my hat. They won't look at me." Mom said I had to go. But I was right; I didn't get the same attention. I was just one of the crowd.

I didn't think I'd get another hat for a while, but my father made Joseph and Chico pay for a new one with their paper route earnings. They said, "Why we got to pay for it?" Dad told them, "This is a lesson. You can't just destroy other people's property." It took three weeks for them to come up with the $2.98. They were angry with me because they couldn't buy their marbles and candy.

Mom got me another hat just like it, except the ribbon and bow were yellow. Joseph and Chico said, "Ha, it's not the same color." I said, "So what? When I grow up, I'm going to buy me a hat *every* day." They said, "That's so stupid." Then I said, "Well, I'm gonna have a lot of hats. And you better not touch them."

Mother Shaw could have given the Queen Mother

a tip or two on how to wear a hat.

JANET OLIVER

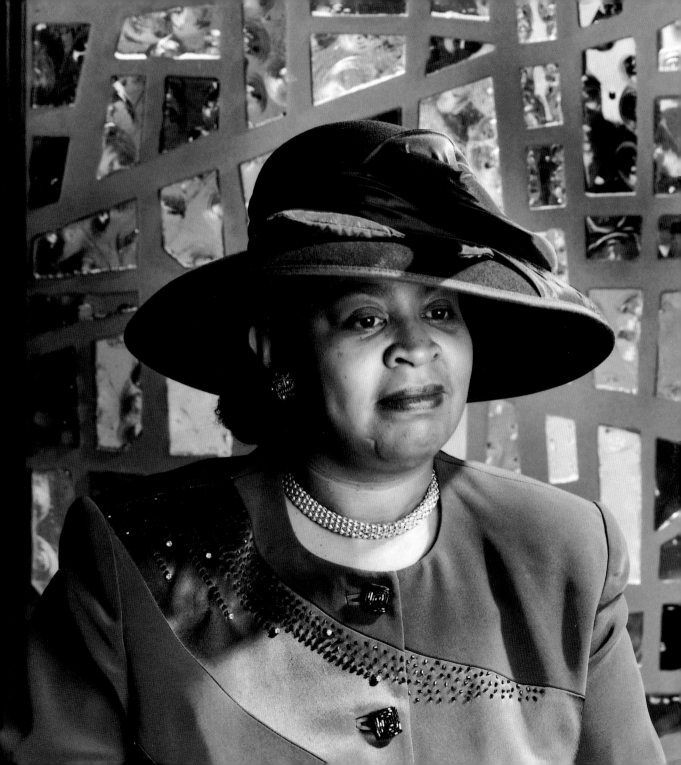

Janet Oliver, 45

SOCIAL WORK SUPERVISOR

*C*hurch of God in Christ women *love* their hats. I've heard preachers say, "Some of you can't pay your tithes, but you wear a new hat every Sunday." Hats and furs. COGIC women love them.

One year, at the annual convention in Memphis, this woman had on a big fur hat and a big fur coat. I looked down at her feet and she had these little fur balls dangling from the back of her shoes. Incredible.

Sometimes people determine whether or not they're going to the convention based on their closet. You're supposed to go to be refreshed and renewed in the Lord, but I've heard many a woman say, "I can't go this year. I don't have the wardrobe."

You talk about a lady in hats: Mother Elsie Shaw. She went to join the Lord several years ago. She didn't wear the flashy where-in-the-world-did-she-find-it style of hat. Her hats always matched the fabric of her suit just perfectly. She was as stately as England's Queen Mother. But Mother Shaw could have given the Queen Mother a tip or two on how to wear a hat.

For years and years, Mother Shaw officiated over my favorite part of the convention: the morning prayer service. It's one of the smaller services. Only about four thousand people. It's a time to meditate on how magnificent God is in your life. Soft organ music played and Mother Shaw would lead us in prayer.

Mother Shaw was from California. She was a piano teacher. She had graceful, gentle gestures and a soft voice. She didn't wear makeup and her skin was fair and al-

most flawless for her age, which was somewhere around seventy. She always wore a serene expression; to look upon her was very soothing. Her title was the National Prayer Warrior, and it fit because nobody could usher in the Spirit like Mother Shaw.

She'd lead the prayer service like this: "The Holy Ghost is here . . . Open up and receive Him . . . Just let Him have His way, Saints." Sometimes she would speak in tongues, which is when the Holy Ghost speaks through you. And the more you'd meditate and praise God, and the more you'd listen to the soft music and Mother Shaw's voice, the higher you'd go. Soon everybody was on one accord and filled with the Spirit. Mother Shaw was truly anointed.

I went up to her one time and said, "Mother Shaw, I want to be just like you." She said, "No, baby. You want to be just like Jesus."

One morning, I arrived at prayer service about six A.M., early enough to get a seat on the floor of the convention hall. I had a great view until this lady sat right in front of me. She had on a great big hat with big red and black feathers all over it. Looked like it could fly.

I was thinking, *Oh, boy. I might as well be up in the rafters because she's blocking my view.* But then Mother Shaw said something like, "He's here . . . He's in the room . . . Reach out . . . Reach out . . . Touch the Lord . . . Worship Him . . . Worship Him." She really ushered in the Spirit that morning and the Lord swept through that place. Have you ever seen those paintings of black people looking overzealous in church, with those long, outstretched limbs? Well, they could have made a painting of that service.

All of a sudden, that woman in front of me took that big hat off and flung it all the way across the room. I said to myself, *Thank the Lord!* I had a wonderful view again and the woman was blessed in the process.

There will never be another Mother Shaw.

don't think that hat cost a whole dollar, but that was

a lot of money. Daddy told Mama,

"If you want the hat, go get it."

CHARLOTTE SWANN

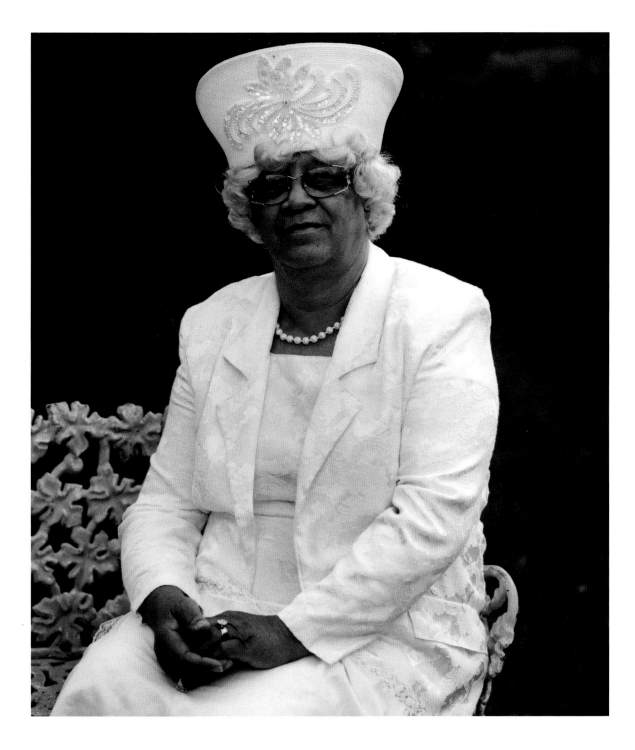

Charlotte Swann, 72

NURSE'S ASSISTANT (RETIRED)

I started pickin' cotton at six or seven years old. It was six of us: three boys and three girls. I'm the youngest. We grew up in Broadway, North Carolina. That's way out in the country. Lee County, down Highway 421. A little community called Buckhorn. There were seven or eight families of black and white. Everybody had their own little plantation. We had land but we didn't have money. My daddy was making 'bout twenty-five dollars a week.

Back then, everybody helped their neighbors. We worked the tobacco together. We picked cotton together. The white people would come help us and eat my mama's cooking; we would go help them and eat their cooking.

Everybody in our family could pick more than two hundred pounds of cotton a day, except for me. I'd crawl on my knees, up and down the rows of cotton. It was just as white and pretty as it could be. Pick it 'n' sack it. Pick it 'n' sack it. Pick it 'n' sack it. I'd get tired and go eat a apple under the apple tree. I guess that's why I couldn't pick but a hundred pounds.

Daddy would get us up early in the morning, just before the dew would dry up. By ten-thirty or eleven A.M, when the sun got up over us and it was hot enough to sweat, we'd head down to the Cape Fear River and fish. We caught catfish and perch and eel— if we could catch 'em. They're first cousins to the snake, you know—hard to catch in fair weather. But when it was cloudy and they couldn't see, they'd be all around the bank.

We'd get back to the house 'bout eleven-thirty A.M. It would be four white men and their families and two other black families. The boys would scale the fish, the girls would cut them, and Mama did the frying. Everybody got a plate and ate together. That was some good eatin'.

Then, we'd go up to the front porch and lay down on quilts Mama had made. We'd nap until two-thirty P.M. and go back to working until it was too dark to see our hands. Dinner was ready at six. The only time blacks and whites separated was to sleep at night. And church. You go to your church and I go to mine. That's the way it was.

Mama always wore hats to church. She made them herself. First time I remember my mama buying a hat was when I was 'bout twelve or thirteen. I went to town with Mama and Daddy. The mules carried us by wagon. It was a two-hour ride to Sanford.

Mama saw a hat she wanted in Elfrid's Department Store. When we got back to the wagon, I heard her tell Daddy 'bout the hat. He said, "Why didn't you get it?" She said, "Well, I was gonna make a hat." I don't think that hat cost a whole dollar, but that was a lot of money. Daddy told Mama, "If you want the hat, go get it."

It was a wide-brimmed, black straw hat. Looked like to me it was a hat you'd wear out in the field to pick cotton. But she put all these colorful silk flowers around it. She got some material and made herself a pretty flowered dress with puffy sleeves and put that hat on her head that Sunday. It was Mother's Day.

Daddy said, "You look good today."

The officer . . . said, "Ma'am, take off your hat." I said,

"Do you know who I am?"

ALMA ADAMS

Alma Adams, 53

STATE REPRESENTATIVE AND COLLEGE PROFESSOR

When I'm in Raleigh, I have 120 colleagues in the General Assembly, and my hats make me stand out. Hats are my trademark. I have over 350. I wear one every day. You could even say I sleep with my hats, because they're in my bedroom. I've had a special closet built for them so that they can have their own space. I have a lot of respect for my hats. They're insured.

A few years ago, I was involved in the KMart struggle, when workers in the local distribution center were fighting for pay equity. One Sunday morning, a group of ministers planned to show their support by getting arrested. I attended the protest. The police came with their paddy wagons. An officer said, "You're under arrest." I put my hands out, he handcuffed me, and they took us in for mug shots.

The officer behind the camera told me where to stand. He said, "Ma'am, take off your hat." It was one of my favorite hats. It has a flat, red crown, a leopard-print band, and a turned-down brim. I said, "Excuse me?" He said, "Take your hat off." I said, "Do you know who I am?" He said, "I don't care who you are. You need to take your hat off." I pouted, but I could see he wasn't playing, so I did what he said, reluctantly. Who would recognize a mug shot of me without a hat?

Just recently, I was at a fundraiser in Greensboro. There must have been five or six hundred people there. A lot of politicians and supporters. Toward the end of the pro-

gram, the chairman approached the microphone and suggested that we take up a collection in support of our fellow North Carolinians in the east, who had fallen victim to the floods following Hurricane Floyd.

The floods were devastating. They caused tens of millions of dollars of damage. The oldest African American town in the state, Princeville, was completely under water. Elderly people who had scrimped all their lives to get ahead were on the roofs of their houses, waiting for rescue boats. Some people lost their homes, their loved ones, cherished mementos. Everything.

So the chairman said, "We're going to pass the hat." Then he said, "Well, does anybody have a hat?" I can't think of *any* occasion where I've taken off my hat in public. Even if I have to scratch my head, I'll stick a pencil up under there.

I stood up. Everybody looked at me. I took my hat off, a charcoal-gray fedora with an upturned brim, and started collecting donations. Everybody applauded.

We raised so much that I had to empty the hat in a basket three times. No loose change. All greenbacks: tens, twenties, a few fifties. We raised about three thousand dollars.

Everybody gave cheerfully. They got really tickled about it. As I walked by, people said, "You mean you really have hair? I thought for sure you were bald." Just goes to show that you can't judge a head by its cover.

Ma Em would take a hatbox from her closet, and

place it in the center of her bed . . .

I couldn't wait to see which one she chose.

INDIRA COOPER

Indira Cooper, 33

ELECTRONICS SALES CONSULTANT

On Sundays, when I was five or six, I woke up at six in the morning to gospel music. Ma Em, that's my grandmother, played those down-home Southern California gospel-choir albums. Or sometimes, she turned on WEAL radio, which carried Reverend Ike, pushing his prayer cloths.

We lived on Ross Avenue in Greensboro in a small house that had only two bedrooms: Ma Em's and mine. On Sunday mornings, Ma Em got up at six to make breakfast *and* dinner. She liked dinner to be ready when we got back from church. I didn't mind getting up early because I got to watch her dress for church. I loved that.

Everything was always in its place in Ma Em's bedroom, neat and tidy, even all the makeup and perfume on her dresser. She had an antique mahogany dresser with a fancy mirror. I played dress-up in front of that mirror many a time.

Her bedroom walls were painted hot pink. She loved pink. And every Saturday, she changed her bedspread, always bright colors: pastels, ivory, white.

After Ma Em dressed me, I'd follow her to her room. It always smelled like liniment and mothballs in there. She'd be in her slip and I'd be dressed but barefoot. I'd run right over to Ma Em's rocking chair and watch her while I rocked.

First, Ma Em would take a hatbox from her closet and place it in the center of her bed. Then, she ironed a handkerchief, folded it, and stuck it in her purse. After Ma Em put on her dress, she'd do her makeup—just a little powder to take the shine off

and a little lipstick and a touch of rouge. No eye shadow because she wore glasses. Then, she picked out her hair; it was short and gray. After all that, Ma Em would sit on her bed and open the hatbox.

I couldn't wait to see which one she chose. She owned about forty hats. Wore them religiously. Fur hats, velvet hats, straw hats. You name it. I liked them all. Except one.

She had a mink hat with the mink's head still attached. Its eyes were wide open. Wide open! That was creepy.

She also had a matching stole for her shoulders. Its eyes were open, too. And it had paws. When I would sneak into her closet, I'd say, "Oh, Lord, don't let that thing fall on me."

When she finally put her hat on, Ma Em had a look on her face that said, "That's the finishing touch." Sometimes she'd stick a pin in her hat, a long pin with a pearl on the end. Whenever she did that, I'd say, "You're going to stick that pin in your head!" She'd laugh. I'd laugh, too. To this day, I don't understand the purpose of that pin. Was it to hold the hat in place or was it just decorative?

When I was little, I thought Ma Em was a real dresser—except for those minks with the eyeballs and paws. Sometimes, I still think about that mink hat and stole. I was so scared of those things back then, but I'd kill for them now.

on't nobody borrow my hats. . . . One time, a

sister-in-law said, "I need a royal blue hat."

I said, "Well, you better buy you one."

BEATRICE GARRISON

Beatrice Garrison, 48

DIETITIAN'S ASSISTANT

Don't nobody borrow my hats. I have about two hundred of them. I've been wearing them for twenty years. I have six sisters. I don't borrow their hats; they don't borrow my hats. That's our way of doing it. I have seven sisters-in-law. They don't borrow my hats, either. One time, a sister-in-law said, "I need a royal blue hat." I said, "Well, you better buy you one."

I'm a nice person, I just keep my hats to myself. I was brought up that way. Leave your personal things at home: your hats, your shoes, things like that. Anytime you lend those things out, people won't give them back and you end up falling out. Keep your things at home and keep the peace.

A sister-in-law of mine borrowed a red leather dress from me two years ago, right, and she still has it. A three-hundred dollar dress. She don't say, "I'm going to bring your dress back" or nothing. They wait for you to bring it up or wait for you to go over and get it yourself. That's not right. You want to help people, but you just end up getting mad at them.

As a teenager, I didn't wear hats to church. I used to wear a huge Afro back in those days, about five inches long. But as I got older, in my twenties, I got married, had a child, and I settled down. I got rid of my Afro and started wearing curls.

One day, I went into a hat store, but I wasn't shopping for a hat. I wanted odds

and ends: stockings, fingernail polish, things like that. Black is my favorite color and I saw a black hat on the shelf. It was felt, with a wide brim, and the crown was kind of squared off. It had a tiny black feather on the left side. That hat was beautiful. I told myself, *I need to start wearing hats to church, anyway.*

When I went to church that Sunday, everybody loved my hat. Our church's first lady, Sister Johnson, she loved that hat, too. Sister Johnson is a special pastor's wife: kind, pretty, very classy. She said, "You give me that hat." I laughed and said, "No, you can't have my hat." She has gorgeous hats herself, but I guess she really liked that style. After that, I went and got plenty of hats.

About six months later, Sister Johnson came up to me. She said that the pastor's anniversary was coming up and she needed a favor. She said, "Can I wear your hat?"

I knew right away what hat she was talking about. I said, "Nobody can wear my hats. But you can." I felt honored. She looked good in my hat, too. She put it on right; she wore it correct. She returned it to me the week after and never asked to wear it again. Sister Johnson was the first person to wear one of my hats . . . and the last.

When [my mother] got a hat, she took care of it. Those hats represented a lot of sacrifices.

SARAH ALSTON

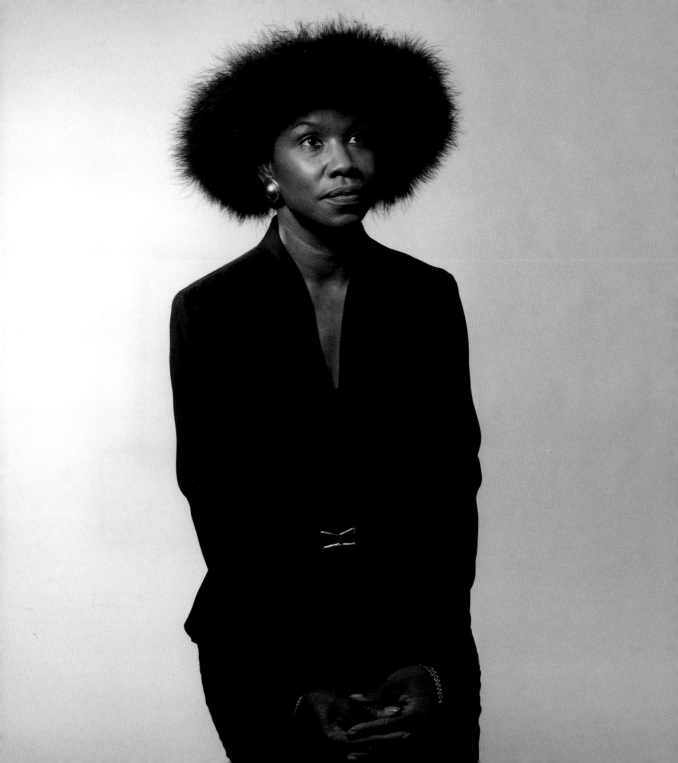

Sarah Alston, 47

MIDDLE SCHOOL TEACHER

I grew up in Gaffney, South Carolina. If you know anything about South Carolina, you know that church women love their hats. We had revivals that lasted all week, and the women had to have a hat for every day of the week, including that special revival Sunday. Nobody had a lot of money, but the women *wore* those hats.

Gaffney was one of those small towns with one high school and two traffic lights. The gas station doubled as the bus station. My father worked at the quarry; my mother was a domestic worker. My parents had nine kids: six boys and three girls. I was the eighth child. Our house was too small for one person, let alone eleven. My parents had their own bedroom and us kids slept five in one bed and four in another. Twin-size beds. And, Lord have mercy, we had one bathroom. We were poor.

My mother was a short, chubby lady. Just like all the ladies in Gaffney, she loved to wear hats. She had about a dozen hats and she always looked so put together in them, so dressed up. I wanted to look like that when I grew up. But I never played with her hats. Oh, nooo! Oh, no, no, no! Not ever. You just didn't do that.

You see, nice things for my mother were difficult to come by; she always put her kids first. So when she got a hat, she took care of it. Those hats represented a lot of sacrifices. She kept them up in her bedroom closet. And you *knew* not to touch them.

Ever since I was a girl, I loved to pamper my mother. I'd do all the extra things. I

even helped her dress. Not that she was an invalid or anything. I just loved to pamper her. Even after I grew up, I'd go back home once a month. She would just brighten up when she saw me. It was her time to get spoiled.

My mother had hip replacement surgery in September of 1992, but she recovered very quickly. Maybe too quickly. When I visited her that November, something was a little off. She seemed distracted. So I said, "Come on here, let me dress you for church."

I did her makeup and I tried to talk about the usual things, but she didn't respond. I zipped her up, made sure she had on her proper jewelry, put a hat on her, a black hat. I remember us wearing black that Sunday; she and I would wear the same colors to church.

She'd usually look things over in the mirror and be satisfied. But on that particular Sunday, something was wrong. It was in her eyes. I think my mother had a premonition that it was time for her to die. That was the first Sunday in November and she died before the third Sunday. I never saw her alive again. She lived to be seventy-three. And like a true Gaffney woman, she wore a hat up to the very end.

It was a real bad-hair day. Of course, I had to

hide it under a hat.

STACEY JENKINS

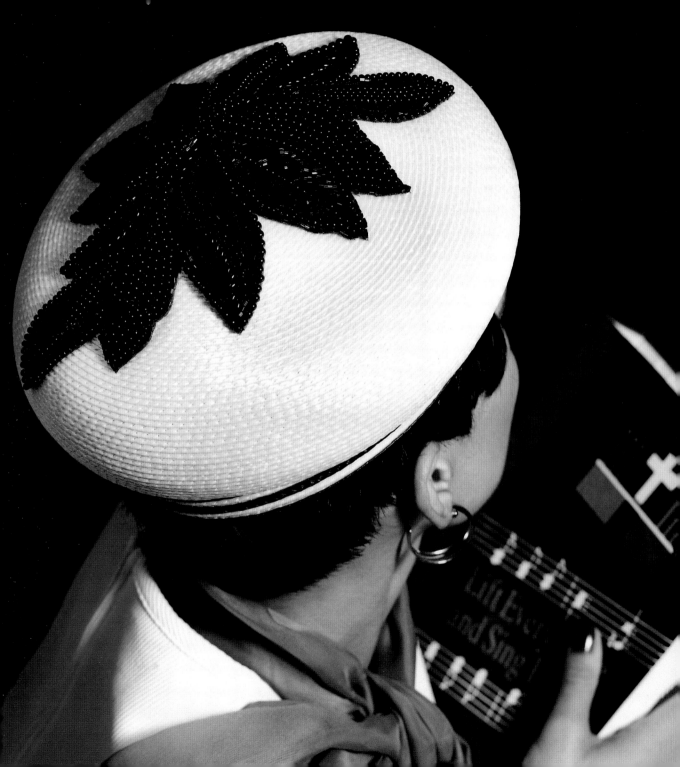

Stacey Jenkins, 22

RECEPTIONIST

Sometimes I think hats were made for bad-hair days. I grew up in Wytheville, Virginia, a small town, maybe twenty thousand people. When I was in high school, I went to church on Sundays—except when I'd meet friends at the basketball court at Scott Memorial Middle School. We liked to hang out there.

I'd just cut my hair this one time. It was shaved in the back and full up top. But on that Sunday morning, I don't know what it had in mind. It was everywhere. That hair was standing up in patches, half feathered, half curly, half straight. It looked rough. It was a *real* bad-hair day.

Of course, I had to hide it under a hat. It had to be a big hat because I don't look right in small hats. I have a big head and big jaws, and small hats make them stand out.

Plus, when my hair is short, little hats make me look like a boy. Everybody says that. This little boy came up to me one time. I didn't even know him, but he put his hands on his hips, looked up at me and said, "You look like a boy." I said, "Thanks."

So, anyway, I put on a tan fisherman's hat, the kind with those flopping brims. It had a blue lining and small air holes all around it. Think I got it at the dollar store. But I didn't care. Anything looked better than my hair. I just put it on and went.

Well, when I got to the basketball court, no one really noticed the hat. But then, I made the mistake of telling my friends that I was having a bad-hair day. So Michael,

who was a year younger than me, and always picking on me, Michael snatched that hat right off my head and took off.

Everybody was cracking up, especially Michael. I chased him all over the place. When I caught him, I beat him to hell. But he kept laughing. So did everyone else. What could I do? I started laughing, too.

I guess some things never change. I still have a bad-hair-day hat. But now it's a navy blue Wu Wear baseball cap, from that hip-hop group Wu Tang. Really, it's my husband's, but I claim it.

Can you imagine if I wore that hat to the Carver School Road Church of Christ one Sunday? I'd have to turn the bill to the side, of course. No, I don't really get with the side thing. I'd have to turn it backwards. I'd be the talk of the church. They'd say, "Whatcha doin', child? Have ya lost yo mine? Girl, we needs ta tawk. Come in har. And take that thang from off yo head."

We decided to put our money together . . . and buy Mama a hat.

Our allowance was twenty-five cents a week.

VELMA WATTS

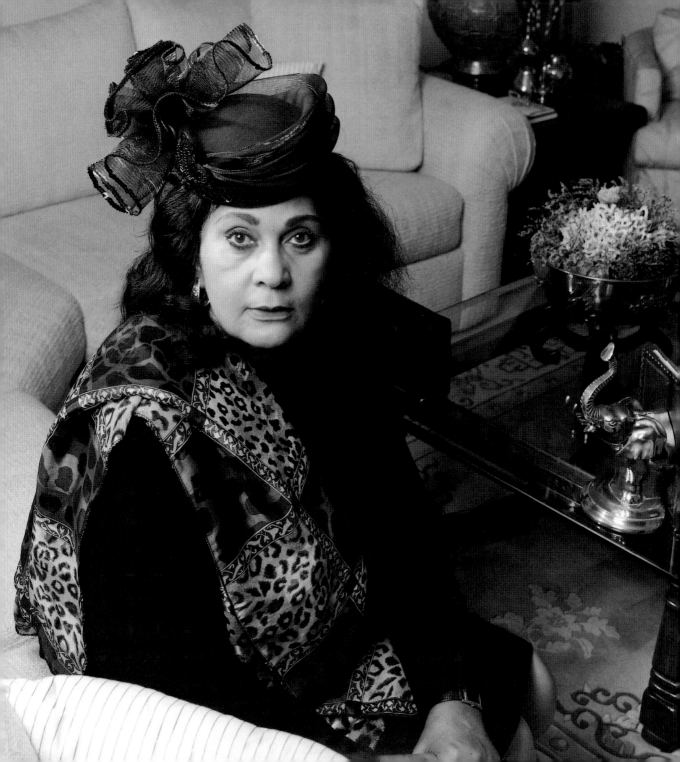

Velma Watts ("A woman who tells her age will tell anything")

MEDICAL SCHOOL ASSISTANT DEAN

My mother died when I was very young, so I was reared by my maternal grandmother. Two of my cousins lived with us because their mother had died young, too. Bobby and Joann. We were reared like sisters and brother. We called my grandmother Mama.

Mama was just beautiful. She was a little heavy—not fat, just heavy. She had Indian features: high cheek bones and a copper-tone complexion. She had graying hair that she parted on the side and tied into a soft twist in the back. She loved hats, but she didn't have but about two or three. That's why my cousins and I came up with our little plan.

Bobby was nine or ten and Joann was my age, seven or eight. There was a special occasion coming up. Maybe it was Mother's Day. We decided to put our money together, without her knowing it, and buy Mama a hat.

Our allowance was twenty-five cents a week. We usually spent it to go to the movies, which cost ten cents; popcorn was another dime and a drink was a nickel. The movies was our usual Saturday outing, but Bobby, Joann, and I decided we would skip the movies so we could get Mama a hat. We agreed to only spend a nickel out of our twenty-five cents until we saved enough money. I imagine it took us about a month. But even so, we couldn't have had more than two or three dollars.

We let Bobby keep the money. But let me tell you, Bobby being the boy, he could con us out of our money. He had a paper route and Joann and I would help him count and deliver his papers, but he never paid us. This time, Bobby did right. He didn't con us out of the money for Mama's hat.

We lived near downtown, so one day, we walked and walked until we saw a hat in a window. We went in, all three of us, and said, "We want a hat for Mama." We showed the lady our money and she sent us down to the basement where they kept their bargains. We saw this pretty white straw hat and we said, "That's the hat! That's the hat!"

When we gave it to Mama, her face lit up. She said, "Is this for me?" She acted like it was the grandest gift she ever received. We were very proud of ourselves. Mama put the hat right on top of her dresser, where it sat and sat and sat. We thought she was saving it for a very special occasion.

Years later, after I got married and had my daughter, Rolonda, I subscribed to a book club that carried the Dr. Seuss series. Well, *The Cat in the Hat* came in the mail and then it all came back to me. That hat we bought for Mama looked like the one the cat had on. It was like a stovepipe. It was about a foot high and flat on top. I said, "Ah, that's why Mama didn't wear that hat."

I like to wear eye-catching hats, but I get embarrassed

when people notice them.

MAERETHA HOPSON

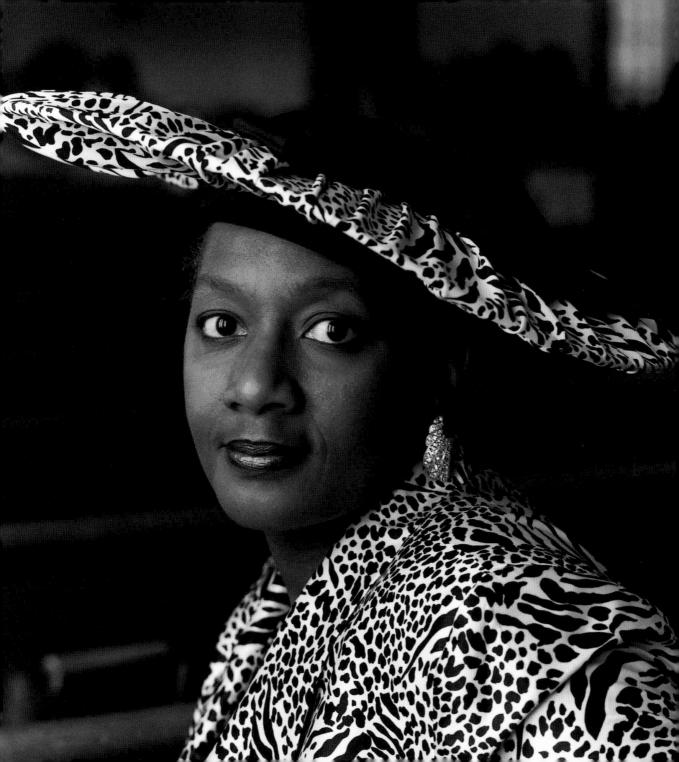

Maeretha Hopson, 47

TEACHER'S ASSISTANT

You can't tell it from some of the hats I wear, but I'm a very shy person. I like to wear eye-catching hats, but I get embarrassed when people notice them. A while back, when I went to my mother's church, I asked her, I said, "Why are people looking at me like that?" She said, "Well, if you're going to be bashful, you sure don't need to wear those big hats and all that wild stuff you wear, those loud purples and oranges." She said, "You might as well get used to it." I'm about to get used to it.

Not long ago, I wore a wide-brimmed hat to church. It was a black straw hat with a low crown and a small black feather in front, also made of straw. When my husband, Michael, and I left church that Sunday, the wind was blowing pretty strong. I could kind of feel the wind getting ready to take my hat off; it was sort of raising up. I should have held it down snug on my head right then and there, but doesn't look cute. I should have known better.

My hair was in small braids that day. When you wear your hair in braids, it's hard to keep a hat in place. Sure enough, next thing I knew, the wind got a hold of that hat and it was gone.

It landed on the sidewalk and took off rolling on the brim. I wanted Michael to run it down, but he was looking at it like it was no big deal. It looked like a wheel, just turning and turning.

If I had run immediately, I could have caught it, I think, but everybody was coming out of church and I thought they'd laugh if I ran. When I'm around a lot of people, I try to be poised. I told myself, *No one will notice if I just walk real fast, bend down real casually, and pick it up.* I said, *Let me just be cool.*

But soon as I bent down, it took off rolling again. It was running from me, like the Gingerbread Man. I walked a little faster, caught up with it again, but the wind gusted again and off it went. It was like that hat was alive.

I said to myself, *Oh God, let me catch my hat because that's a hundred dollars rolling down the street, and after a while, a car's going to run it over.* All I wanted to do was pick up my hat and go home. But it just kept rolling. I finally thought, *Okay, let's just go ahead and get bad with it and take your heels off and run.*

When I finally caught up to my hat, I put it back on, nice and tight, and kept steppin' to the car. Never looked back. I didn't even *try* to look around to see who saw me. I was thinking, *If I can't see you, you can't see me.* No one ever said anything to me about it, but every time I wear that hat I wonder if anyone remembers.

I've redecorated a lot of my hats . . . I have one that I've done

over and over for thirty years.

ANN HANES

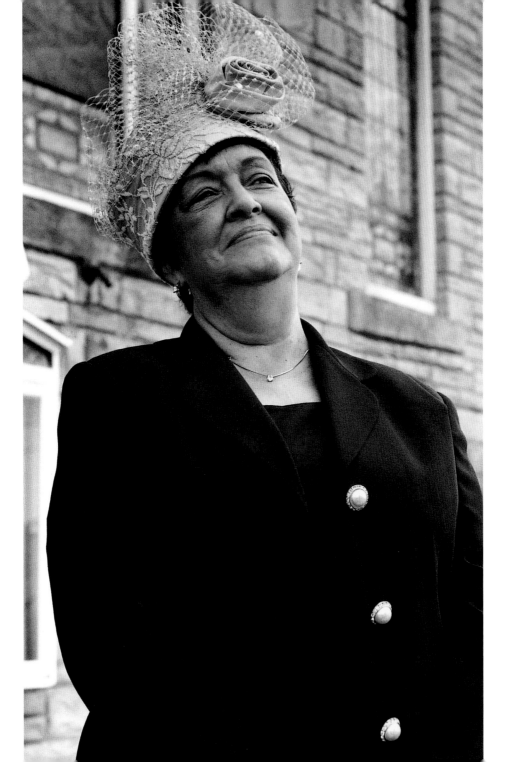

Ann Hanes, 66

MANUFACTURING PRODUCTION MANAGER (RETIRED)

I have an old, old hatbox that is full of junk. I know it's at least thirty years old, and so is a lot of the junk in it. It's stuffed with burgundy ribbon, sequins, gemstones, blue feathers, white feathers, and little pieces of fur. A little bit of everything. Every now and then, I go to that box to re-create one of my hats.

I have about a hundred hats. I have so many because I don't let them go. I don't usually throw away a hat unless it has an extreme style that won't come back around. But any other hat, I can pull something off it and add something else and be in style for the next season.

I'll snatch a ribbon off one hat and tie it on another; I'll get a bag of feathers and glue them on a hat one at a time; I'll buy a can of spray paint and change the color of a hat. I've redecorated a lot of my hats more than one or two times. I have one that I've done over and over for thirty years. It's a navy pillbox hat that I got before Jackie Kennedy made them famous.

Most dress hats are very, very expensive: They cost about a hundred dollars. That's why I don't throw them away. Because when I spend a hundred dollars for a hat, I'm going to get a hundred dollars out of it. I get a lot out of my materials, too. If a silk flower gets mashed in my old hatbox, I just fluff it out like I want it and put hair spray on it to hold the shape and it's good as new.

Word gets around. A lot of people at my church know that I do hats. A friend of mine, Kennetta, brought me one of her hats a couple of months ago. She knows that I'll make one over in a minute. I was in Bible study and she sat a shopping bag next to my chair. We didn't talk right then. Later that night, she called me on the phone and said, "Have you looked at my hat? I know you can fix it." Then she told me her story.

Kennetta had left her hat on her bed and her puppy got a hold of it and chewed that hat up. Her grandchildren had given the puppy to her for her birthday. She paid a lot for that hat and only got to wear it one time, so I was determined to save it for her if I could.

It was a fuchsia straw hat, a skullcap shape with two big fuchsia flowers on the side. I put the hat on my Styrofoam head form and steamed the wrinkles out. I knew I didn't have any fabric in my old box to match the color, so I bought some fuchsia ribbon: number five grosgrain ribbon, which is about one inch wide. I created a sunburst design on top of the cap to cover up the bite marks. It took me about an hour. When Kennetta saw what I did, she said, "Girl, you can do anything!"

The hat I've got on in the photograph is a new hat. I probably won't bother with this one for a while. Not this year, anyway.

Later on, as my children grew up, I really got into hats. I have about fifty hats now in every color.

RITA JOHNSON

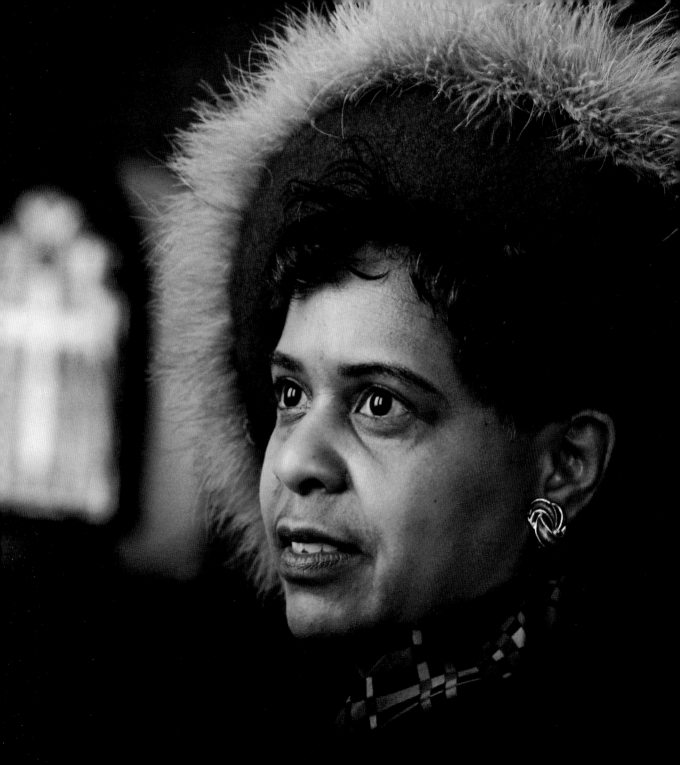

Rita Johnson, 48

Bank administrative specialist

I didn't even like hats until I was an adult. I grew up in the New Bridge Baptist Church, a small church in Richmond, Virginia. When I was maybe six or seven, my mother wanted me to wear a hat for Easter Sunday.

It was a little white hat that looked like a sailor's cap. My mother propped that hat on my head and it just didn't fit right. My hair was long, so she would put it in pigtails. The hat felt so uncomfortable with those pigtails, and I felt like it would draw attention. I hated it. I hated all hats.

I was the only girl in the family, so of course my mother dolled me up. Even though I was older than my two brothers, I was the little doll baby of the family. My mother took pride in dressing me up. My little dresses were always starched and crisp.

So my mother really wanted me to wear that sailor's hat that Easter. But I knew people would look at me and say, "Oh, don't you look cute." And I'd think, *This ol' hat, I'd like to take this thing off my head and throw it somewhere.*

My mother said, "The hat looks nice."

I said, "But I don't think the hat looks nice."

She said, "You'll look cute."

I said, "But I don't want to look cute."

She said, "Just wear it for this one occasion. How about that?"

Well, you know, you didn't do too much arguing with your parents back then, so I gave in. When my mother left the room, my eyes got full of tears. I wouldn't let her

see me crying. If she knew how much it hurt me, she wouldn't have made me wear it. I always tried to please my mother. But after church was over, that hat came off. She never made me wear it again.

As I grew older, I first wore hats out of a sense of duty. I got married when I was twenty. My husband had just been ordained, so I wore hats because I was the minister's wife. The Bible said that a woman's head should be covered and that a woman should adorn her hair, so I never cut my hair and I wore hats.

Then I actually began to like hats. But I couldn't really afford them, so I didn't have that many. We were a young couple and my husband was in college. We were struggling. Poor as poor could be, but I was happy as a lark with my three hats: a white, a red, and a black.

That was fine because I didn't have that many clothes, either. I wore something white with the white hat for communion and for weddings or other special occasions; something black with the black hat for funerals; and something that would blend in with red, the fun hat.

Later on, as my children grew up, I really got into hats. I have about fifty hats now, in every color. After all this time, I finally think I look nice in hats. According to Mom, I always did.

I'm six feet one. I like low hats and tams because they

don't make me look any taller.

MARY JORDAN

Mary Jordan, 62

REGISTERED NURSE

Low tops and wide brims. That's the kind of hat I like because I'm a tall person. I'm six feet one and a wide brim and low top just suits me better. If I wear a hat that just goes straight up, it adds to my height.

Half my family is tall. I'm the oldest of nine. I have a sister and two brothers who are my height and I have a brother who's six foot seven. I had to learn to adjust to my height at an early age. I was always taller than everyone else in my class, even from my primary school grades.

When we performed little dances and things, I always stood out. Kids are cruel, whether you're tall or you're small. They called me string bean, giraffe, anything like that. I tried to ignore them so it wouldn't really affect me.

Some tall girls try to look shorter by hunching their shoulders over. But when I was growing up, you didn't slouch down. My parents would always encourage me to have good posture: "Hold your shoulders straight up. Breathe in. Walk straight."

I used to be kind of timid, but I soon grew out of it because there's nothing you can do about your height, except make the best of it that you can. I got comfortable with my height when I was about sixteen. I had survived the cruel stages in school. In high school, all my friends were shorter. Looked like I attracted short friends. And that made me look even taller.

When I got to be around sixteen, I started wearing the makeup and the earrings and the other little things that you choose to look nice. That's when I started wearing hats. French tams were in at that time. I always liked tams because they fit flat down on your head, so it didn't make me look any taller. They looked better on me than anything else.

We used to have fifteen-cent dances at the recreation center. I can remember going to a little dance one time. I had a tam on and a boy asked me to dance. I don't remember his name. I was dancing with the boy and he was a little shorter than me. He wanted to get some laughs so he had nerve enough to lay his head on my shoulder. Everybody started howling. I hauled off and slapped his face and walked off the floor. He was trying to be funny, but I got the last laugh.

I don't feel bad about my height, but I don't want to look any taller. If a hat goes straight up, I just avoid it.

e just know inside that we're queens. And these

are the crowns we wear.

FELECIA McMILLAN

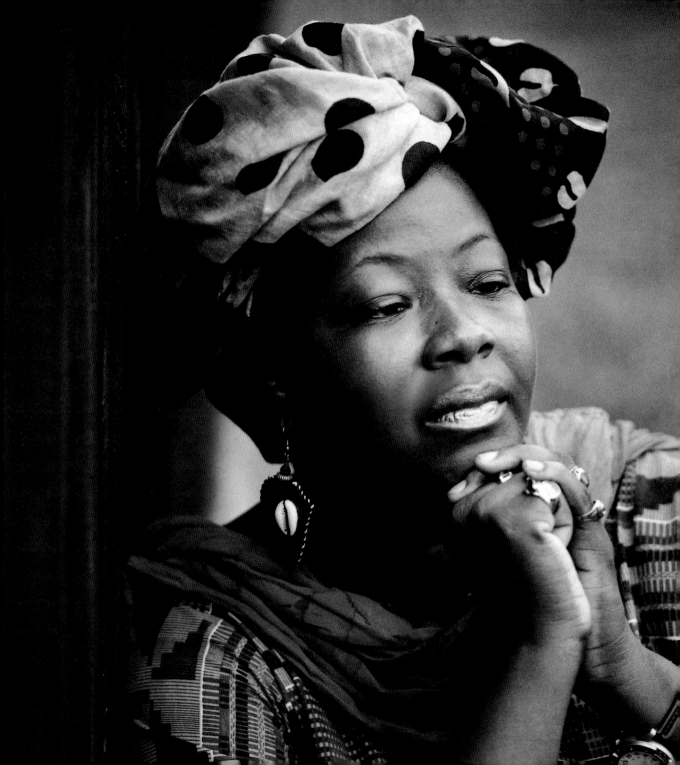

Felecia McMillan, 39

JOURNALIST

During the Thanksgiving holiday in 1990, my brother Kermit was murdered. He was twenty-nine. He had an argument with a friend and the friend shot him in the abdomen with a rifle. It was a great loss to our family. It was a great loss to me.

When we were growing up, everyone thought Kermit and I were twins, even though I was a year older. We had a strong bond. We were the youngest of five. Our other siblings were five years older than us and more. Kermit and I called ourselves "the little people" because we could crawl between the legs of all the giants in the house.

As we grew up, we were striving to "become" at the same time. But when we went to college, he began to choose some different friends. That took him down a bad road. It was something I couldn't control.

I was at my mother's house one night, making deviled eggs, when I heard a knock at the door. It was one of Kermit's friends. He told me Kermit had been shot. We went to the hospital, but Kermit died before we could see him.

I haven't eaten deviled eggs since.

After Kermit was killed, I was looking for answers, looking for myself. I got involved in a school on Saturdays to learn about African history. That's where I learned to appreciate African attire. One day, I bought a beautiful, flowered kemet jumpsuit with a matching jacket. It also had a matching gélee headwrap. The fabric had tiny magenta flowers and avocado-green leaves, with a gold border around the foliage. The pat-

tern was the same color on both sides of the fabric. My African friends say that's a sign of authentic kente cloth. It's a sign of quality.

I decided to wear the whole outfit to school one day. I taught English at Mount Tabor High School. I felt nervous about how people might react. One of the teachers, a history teacher, she said, "I guess you can pull off any look. Yesterday you had on your professional navy blue suit. Today you have on your jungle-bunny outfit."

I just looked at her. She was black, also, and I didn't know what she meant. Then she said, "You know, I like your costume." I said, "This is not a costume. It's African attire and I'm making a connection with the heritage of our people."

The more I study Africa, the more I see that African Americans do very African things without even knowing it. Adorning the head is one of those things, whether it's the intricate braids or the distinct hairstyles or the beautiful hats we wear on Sundays. We just know inside that we're queens. And these are the crowns we wear.

I greeted my students at the door in my gélee. They loved it. They said, "Hey, Miss Mac! Let me rock that brim." They all wanted to try on my gélee—boys and girls, black and white.

I have a large collection of hats: about sixty church hats and maybe twenty gélees. But I find myself wearing my gélees the most. They connect me to the Motherland. They connect me to myself. And, in a way, they connect me to my brother because they connect me to all ancestors who've crossed over.

 y husband said . . . "You don't need another hat.

You don't have but one head."

DOROTHY WYNECROFF

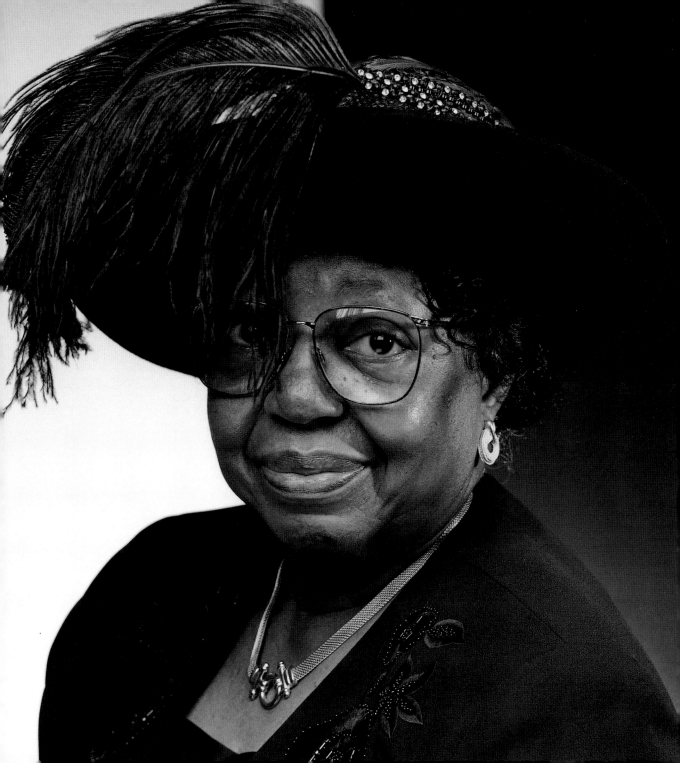

Dorothy Wynecroff, 73

MIDDLE SCHOOL TEACHER (RETIRED)

*T*here was a time when I had to slip my hats into the house. I owned about two hundred hats and my husband said that was enough. He'd say, "Don't bring another hat in this house." So I'd leave them down at my sister's and bring 'em home when I could. At first, he didn't pay too much attention to my hats. He didn't notice them until they started crowding in on him.

I've been married forty-seven years. He's been a good husband. Donnell is his name, but everyone calls him J.T. I was twelve the first time I saw him, but I had a likin' for his older brother, Prelow.

When I married J.T., I don't think I had but a dozen hats. I was a clerk at Kate B. Reynolds Hospital. I didn't buy too many hats because I worked every other Sunday and couldn't go to church. Wouldn't have had anywhere to put them, anyway. We lived in a three-room apartment. We stayed there a couple of years and, in 1954, we built a two-bedroom house on Graham Avenue.

We were on a strict budget after we built that house, so I still didn't buy too many hats. But I started teaching in 1963; I was making a little more money, so I could afford them. I started buying about ten or twelve hats a season. My husband said I had too many. He'd say, "You don't need another hat. You don't have but one head."

After fifteen years, we built a bigger house and I started buying more hats. I

started out keeping them in my bedroom closet. Then I put some in the guest bedroom. Then I put some in a storage area off the garage. Then I built shelves in the basement. My husband would say, "Where'd you get that one?" I'd say, "Oh, you seen it before." He'd say, "No I haven't. Where you gonna put it? Ain't no room now." I'd say, "Well, I'll make room." But he was right. The house *was* crowded. That's why I started to slip them in.

I'd leave hats at my sister Olivia's. She'd say, "Oh, here you come. What you got?" I'd show her. She'd say, "My goodness. Another hat." Olivia is my critic. She'd compliment me every once in a while, but sometimes she'd say, "Don't bother hiding that one. Take it back."

I'd leave them at her house only a day or two. My husband used to own a laundromat, so when he'd go down there at night, I'd go over to Olivia's and bring the hats.

I don't do that anymore. I just bring the hats in. One day I said, "It's my money I'm spending. And it's my house, too. Go on and say what you want to say. I ain't taking my hat back." He got mad but he left me alone. Said he couldn't do nothing with me. Now he doesn't say too much when I get a new hat. He just looks.

My grandmother wore hats to church. She used to say,
"A fully dressed woman always has on a hat."

MABLE SCOTT

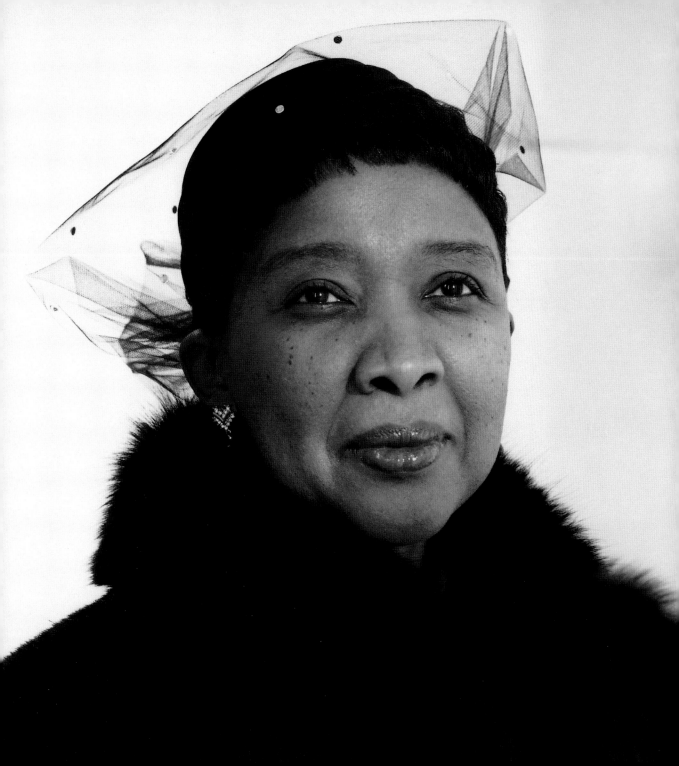

Mable Scott, 48

UNIVERSITY PUBLIC RELATIONS DIRECTOR

I was raised in Memphis, Tennessee, and started working when I was three. My grandmother raised me. She worked for her brother, who was a dentist, because he couldn't afford a real staff. His office was on the corner of Beale and Third. That's where you'd find all the black doctors, lawyers, movie theaters—on Beale Street. Everything that white people had on Main Street we had on Beale Street.

Growing up, we didn't have day care centers, so I went to work with my grandmother. She assisted my uncle when he was cleaning and pulling teeth. My job was to keep the patients in the outer office from running out the door. From the sounds you'd hear, I don't think my uncle had a lot of anesthesia. I learned all these Bible verses and dance steps and songs, anything to keep the patients entertained. I would sing songs like:

> *Jesus wants me for a sunbeam,*
> *to shine for Him each day.*
> *In every way try to please Him,*
> *at home, at school, at play.*
> *A sunbeam, a sunbeam.*
> *Jesus wants me for a sunbeam.*
> *A sunbeam, a sunbeam.*
> *I'll be a sunbeam for Him.*

My grandmother and I lived in the Foote Homes, one of the government housing projects. It was downtown, the closest projects to the Lorraine Hotel, where Dr. Martin Luther King was killed when I was a teenager. Kids in the projects always looked forward to three times of year: In May, the Cotton Makers Jubilee would come. It was like our Mardi Gras. In July, Independence Day was always a big time. And in November, we knew the Saints were coming to town.

Even though I was Baptist—I grew up in the the First Baptist Church of Lauderdale—I always looked forward to the Church of God in Christ (COGIC) Saints coming to Memphis for their annual convocation. Tens of thousands of black people would converge on Memphis because Memphis was where the Church of God in Christ was founded.

We kids had never seen so many long, black Cadillacs and women with diamonds and mink coats and mink hats. We all thought, "Oh my God, everybody in the Church of God in Christ is rich!" For kids running around the projects with next to nothing, it was a wonderful thing to see. We'd stand on the side and say, "None of that pie in the sky in the sweet by and by. They got the pie now!" The black community just became aglow when the Saints came to town.

My grandmother wore hats to church. She used to say, "A fully dressed woman *always* has on a hat." But she wore conservative hats. Not like the fancy ones the COGIC women would wear.

When I married, my husband and I became members of COGIC. It had nothing to do with fine hats or long cars. I was hungry for the discipline and the biblical teachings. Now I know everybody in COGIC is not rich. They just have a lot of nice things to wear to church. And even today, just like when I was a little girl, Memphis becomes the hat capital of the world every November.

This was one of my mother's favorite church hats . . .

She purchased it in the 1950s.

DOROTHY WALLINGTON

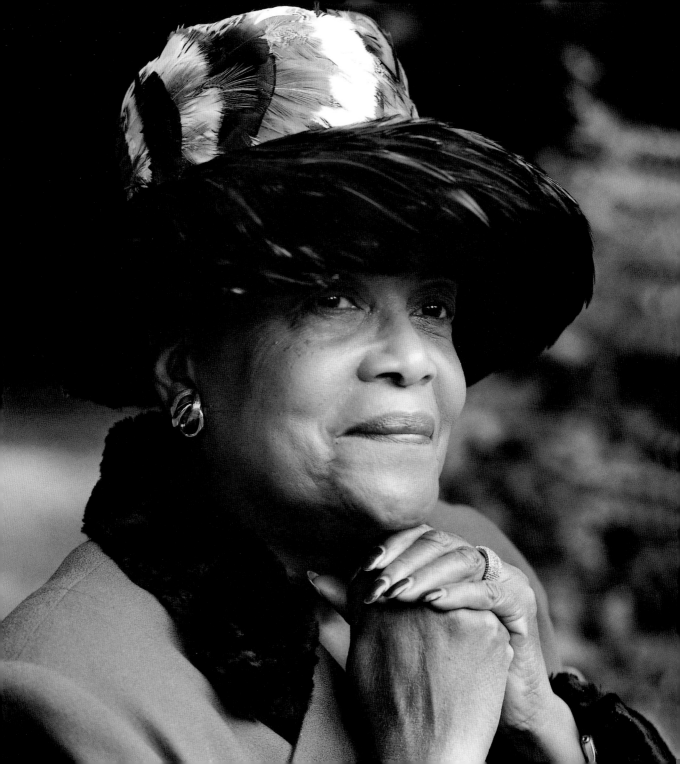

Dorothy Wallington, 69

BANK LOAN PROCESSOR (RETIRED)

When people compliment me on this hat, I say, "This was one of my mother's favorite church hats." Nobody can believe it's that old. She purchased it in the 1950s. The label inside says "Christine Original. Park Avenue." Altogether, she had about a dozen hats.

My mother, Lilly Hutton, liked the finer things: china, crystal, furs. The best. She worked as a housekeeper for white people and they had those things and she thought, *There's no reason why I can't have them.*

For about forty-five years, my mother worked for Dr. and Mrs. J. N. Caudle. He was James and she was Elizabeth, but my mother always referred to them as Dr. Caudle and Mrs. Caudle. He was a dentist. Mrs. Caudle was always home and, as my mom said: "All she did was sit on her behind and read."

My mother did the cooking and everything. Sometimes she would even prepare food for Mrs. Caudle's garden club or church group. They loved her pinto beans and her corn and her coconut cake. Everybody just raved over Lilly Hutton's food.

The Caudles had two children, Michael and Priscilla. Michael was like my mother's little boy. He loved Lilly Hutton. He'd be right up under her. He was so bashful. He wouldn't talk to anybody but Lilly Hutton.

The Caudles had a modest home, but it was filled with things that my mother admired: Persian rugs, antique furniture, fine china. If she saw something she really liked

in their home, she would go out and lay it away and pay on it until she could get it out. That was a way of compensating herself for her hard work.

The Caudles were very generous. They gave my mother a lot of fine things for her birthday, nice things from stores that blacks couldn't go in. Mrs. Caudle gave my mother some of her hats, too. But they were smaller hats, and my mother was always one for big, show-off hats. I don't know what she did with those little hats.

If Mrs. Caudle was entertaining, my mother would wear a uniform. But other than that, she would just wear an apron. Sunday would be a time for my mother to get dressed up. But even when she wore nice things, like this hat, she was always herself. She never put on airs.

This particular Sunday, my kids went to church with my mother. Chuck was about ten; Clara was about eight. Being the oldest, Chuck always rode in the front seat and made Clara ride in the back. He was pretty hard on Clara. Chuck always wanted to jump out of the car and beat Clara to the house. When they got back to my mother's house this Sunday, Chuck jumped out of the car and stepped on a snake. My mother had a lot of bushes and things around her house. Well, when Chuck saw that snake, he jumped right back in the car and nearly passed out.

My mother went and got a shovel and killed the snake, in her fine hat and all. Then she said, "Come on little children. Let's go in the house." All dressed up and killing a snake. She was really something else.

I'm blessed to still have her hats. They're heirlooms, just like the china and crystal. Lots of family history. I hope to one day pass them on to Clara. Clara doesn't wear hats, but I'm hoping she develops an appreciation for them, so when people ask, she can say, "This was one of my grandmother's favorite church hats."

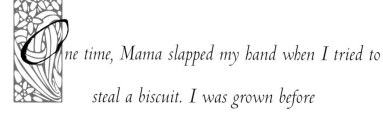 ne time, Mama slapped my hand when I tried to

steal a biscuit. I was grown before

I decided Mama was blind for real.

JIMMIE RUTH JONES (LEFT)

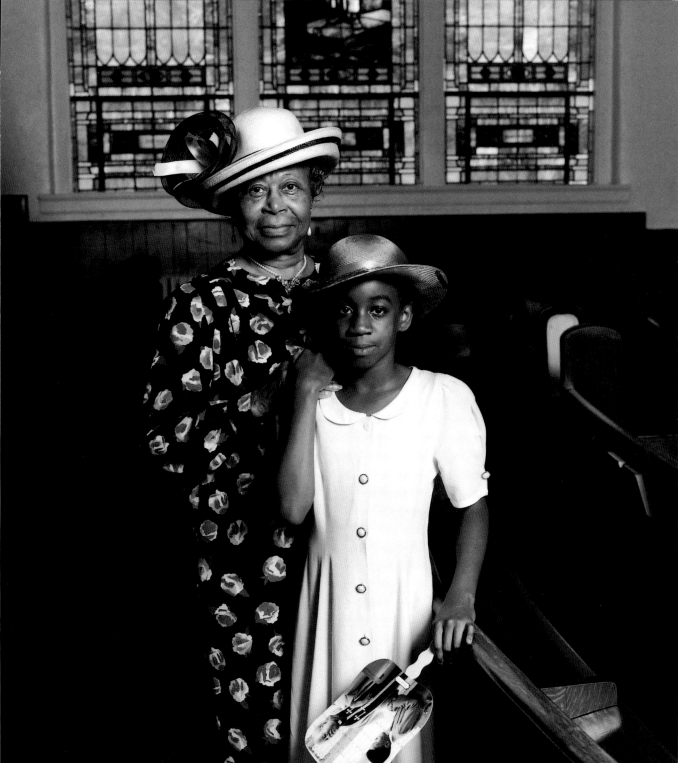

Jimmie Ruth Jones, 78, with granddaughter, Bridgette

HOUSEWIFE (RETIRED)

My mother went blind from glaucoma when she was twenty-six years old. Daddy carried Mama to the doctors 'bout every month, but they couldn't do nothing for her.

She had seven girls and one boy. Five of us came along after she went blind, including me. I was born in Nashville in 1920. We lived in a rural district outside Nashville called Fayettville.

Farmers didn't have a lot of money, and my father was a farmer. We lived in what they called a shotgun house: all the rooms were in a straight line. We didn't have running water; you had to walk to the spring. But we were happy.

We'd sit around the potbelly stove and listen to Mama and Daddy talk about the olden times. They laughed about how Daddy came calling and Mama's mother liked his prospects. She told Mama if he came calling again Mama would have to talk to him, whether she wanted to or not.

When you were born and raised in the country, how many rugs did you see on the floor? Our floor was bare board. How many walls did you see covered with wallpaper? We had cardboard and newspaper on the walls. But my mother taught me how to read from those newspapers.

I'd lay down on the bare floor and look up at Andy Gump and the rest of those funny pages. I'd tell my mother 'bout how a letter of the alphabet was shaped, and she'd tell me what it was. Eventually, I could spell the words and she'd tell me how to say them. Remarkable lady.

Mama would have us stand by the stove to fan the flies, but she didn't need our help cooking. She could fry chicken or roast beef all by herself. She could even tell you which one of us walked in the door by our footsteps.

When we went outside to play, she would come along and lay her hand on your shoulder and run right along with us. One time, Mama slapped my hand when I tried to steal a biscuit. I was grown before I decided Mama was blind for real.

Sometimes Mama would cry. I remember, I was a still a little girl, and I said, "Mama, what are you crying about?" She said, "I wish I could see." I said, "God took away your eyes and gave you eight pairs more." She said, "Ain't nothing like having your own eyes." Sometimes she'd get so mad she'd go turn over Daddy's shaving dresser. But most of the time she didn't dwell on being blind.

On Sunday mornings she'd go in and take her own bath, and you better not come near the door. She thought nakedness was just a sin.

She had a great sense of feel and she'd pick out her own dress. She'd ask us, "Is there any dirt on this dress?" Then you had to powder her face.

Mama liked to put her hat on by herself, but she looked to you to straighten it out for her. She didn't have too many hats, but she wore one every Sunday. *Every* Sunday. You didn't take her to church bareheaded.

When we looked her over and told her she looked all right, she was comfortable. She'd get your arm and we'd go on to church. Mama was an extraordinary woman.

That hat didn't have nothing. It didn't have no veil . . .

It didn't have no feathers.

All it had was a lot of ugly.

SANCLARY SAUNDERS

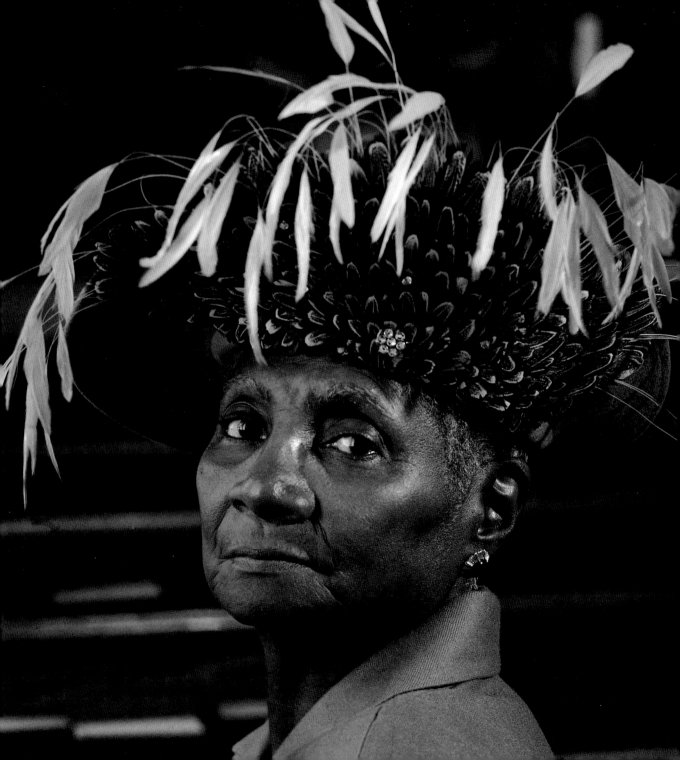

Sanclary Saunders, 68

PRINTING COMPANY EMBOSSER (RETIRED)

My sister-in-law, Carolyn, she sells clothes, hats, and things. If she has something she thinks I'll like, she'll bring it by. I just started wearing hats three years ago. I like the odd ones. One day, Carolyn brought me an odd hat to look at, but it was too odd for me. It was the ugliest hat I've ever seen in my life.

It was a big ol' awkward-looking hat. And I mean big. I like big hats, now. But this hat was huge. I called it a tub 'cause it looked like you could bathe a dog in it. It was wider than my shoulders. That hat wouldn't even fit in a hatbox; Carolyn brought it over in a big plastic bag. I don't think they've *ever* made a box big enough for that hat. It was heavy, too. Felt like somebody was sitting on top of my head.

I really didn't know what to wear with it. It was made of felt—a brownish beige, like mud. Didn't have any life. That hat didn't have *nothing*. It didn't have no veil. It didn't have no band. It didn't have no feathers. All it had was a lot of ugly.

I think Carolyn only wanted forty-five dollars for it. But I didn't care if she didn't want but a dollar. I didn't want it. I told her, "I don't know where in the world you got that hat from 'cause it don't look like *nothing*. At least, it don't look like nothing on *me*." I said, "Honey, I don't want this hat." But she said, "I'm going to leave it here for a while and it might grow on you."

Some days, I'd go and try that hat on. But it didn't look no different and I put it

right back up in that closet. I showed it to my daughter. She said, "Mama, please don't buy that hat." I told her, "I'm glad you thinking the same thing I'm thinking. This is one ugly hat."

I guess if I had propped that thing on my head, people would have said, "I wonder where that crazy lady is going wearing that ugly hat." And at church, I'd feel sorry for the people sitting behind me. They'd be tapping me on my shoulder, "Excuse me, I can't see the pastor around your big, ugly hat."

Carolyn left that hat with me for about three months. I called her up and said, "Come and get this hat out my closet 'cause it's taking up too much room." She said she thought it was a nice hat. I told her that if I went to church in that hat, they'd put me out. I don't want it. Period. She came and got it one weekend. She said, "You sure you don't want it?" I said, "Uh-huh, I'm positive. Ain't no way. Wouldn't wear it to a pigpen." I don't know what they were thinking when they made that hat. Don't think they were thinking at all.

Thanks and Acknowledgments

FROM MICHAEL AND CRAIG:

This book would not have been possible without the help of so many, whom we both would like to thank: our fifty newfound friends, the beautiful hat queens featured in this book; our brilliant editor, Janet Hill, and her assistant, Roberta Spivak, who understood our vision and championed it as if it were their own; our design director, Maria Carella, for her beautiful and creative interpretation of our work; and our mutual friends Paula Robinson, Chuck Wallington, Beth Hopkins, Lisa Wimbush, Sharon Hodge, and Sherrie Flynt-Wallington for all they did to help, guide, and support us. Thanks also to Victoria Sanders, David Mayhew, and Selena James for embracing and promoting this book.

FROM MICHAEL:

Thank you God Almighty for granting me this gift and allowing me to share it. Thanks also to my brothers and sisters: Dennis Jr., Brenda, Juanita, Ersell (follow your photography dreams), Thomas, and Taricia. Thanks to my dad for the entrepreneurial gene and to my mother for sharing her values and inspiring my love and respect for all

women. Thanks to Ernie and Elaine Pitt, who, when I was twelve, gave me my first 35mm camera and a job at their newspaper.

Thanks also to photographer A. Doren and his wife, Caroline, who encouraged me from the start; Jaeson Pitt and Tirso Martinez, who were my photo assistants; LaShonda Fields for her fantastic public relations skills; the gang at Carolina Camera and Superieur Photographics for their great service; my printers, Jerry MacFarland and Elizabeth Banks.

Thanks to the entire staff at the Delta Fine Arts Center in Winston-Salem and to curator Deborah Willis and director Steve Newsome at the Smithsonian's Anacostia Museum and Center for African American History and Culture in Washington, D.C.

Thanks to Bud Baker and Ken Fleming of Wachovia and John Cox of Sara Lee for their sponsorship and support.

Thanks to my friends for being there: Michael and Debra Pitt, Derek and Tonya Caldwell, Brooke Anderson, Gloria Lindsay, James Parker, Camille Roddy, Jerry McLeese, Sheran Thompson, Janice Wall, Leslie Eaton, Rev. John Mendez, Rev. Wendell Johnson, Audrey Easter, and all of the Trade Street artists.

Thanks to Craig Marberry for sharing your enthusiasm and your God-given talent. A special thanks to Tanya Robinson for being by my side.

And to my daughter, Kamari, my princess. Daddy loves you!

FROM CRAIG:

To God be the glory. To His angels, my boundless gratitude, beginning with my mother, Janet Grace Hill, who taught me that God's dreams for us live within us. To my father, Fred Marberry, who, when I was in high school, sometimes pretended to be too busy to draft his newspaper column and asked me to write it instead.

To my grandfather, the late Bishop Louis Henry Ford, who taught me that Jesus never fails, but lazy kids do. To my grandmother, Margaret Ford, who always has a place for me on her lap and in her heart. No woman has ever worn a church hat with more elegance. To my loving brothers: Marc, Dana, Glenn, and Nolan, who lives on in my heart; and to my lovely sisters Kim and Gia. Your devotion inspires.

To Uncle Charles for letting me win those foot races on Parnel Street by a nose; and to Aunt Marlene for sharing her infectious laugh and her divine sugar-pecan cookies, if not her recipe. To my late godmother Ada Kimbrough and the entire Kimbrough Klan. To Renee Geeta Marberry and Kelly Lucas for their steadfast faith and support. To Robyn Chester for her indulgent ear. To the Wallingtons, my adopted family, for making a Chicago boy feel at home in North Carolina. To all the Marberrys, Fords, Littles, Austins, Andersons, Woodys, Hills, Lucases, Chesters, and Porcos who populate the family (and like-family) tree.

To my favorite teachers: Mrs. Chestang, who somehow saw potential in the dazed eyes of a wayward eleven-year-old. To Mrs. Clark, who sacrificed her lunch hour to teach me chess and the power of reason. To Mrs. Crawford, who made me stand when tardy for her English class, even though it broke her heart. To Dr. Stevens at Morehouse College for asking me to read aloud my paper on Langston Hughes's poem "Harlem." And to her colleague, Dr. Lutton, for posting my first published essay on her office door. To esteemed Columbia University journalism professor Phil Garland, whose eyes gleamed with pride when she read my unexceptional news reports.

To James and Imogene Harris for giving a high school sophomore his first job in journalism. To Eleanor Hamill for giving me, fresh out of college, my first job as a writer.

To Elizabeth and Gerry Gutierrez, Yvonne Barrett, Don and Elizabeth Swaim, Jim and Laura McSorley, Eileen Vladitch, Stella Stotts, Belinda Brown, and Leon, Von, and Mikayla Kinloch for their long and cherished friendship. To Cynthia Cruz for her

eagle eyes and joyful soul. To Dr. Robert Franklin, my beloved mentor and friend. To friends and authors Clare La Plante, David Dent, Michele Nayman, and Yolanda Joe for their wise counsel. To all the Saints at Saint Paul Church of God in Christ in Chicago who, no matter how long my absence, always greet me like the prodigal son.

And to Michael Cunningham—my colleague, my brother. May God continue to shine on you.

You all mean so much to me. Thank you, Lord. I am truly blessed.

A BOUT THE A UTHORS

Michael Cunningham is a commercial photographer whose clients include Coca-Cola and Sara Lee. Two of his photographs are currently on loan to the Smithsonian's Anacostia Museum, and his works have been featured in the *New York Times* and *Ebony.* He lives in Winston-Salem, North Carolina.

Craig Marberry, a former TV reporter, holds a master's degree in journalism from Columbia University and is the owner of a video production company. He has written articles for the *Washington Post* and *Essence* magazine. Marberry is also the grandson of the late Louis Henry Ford, former Presiding Bishop of the Church of God in Christ. He lives in Greensboro, North Carolina.